★ ICONS

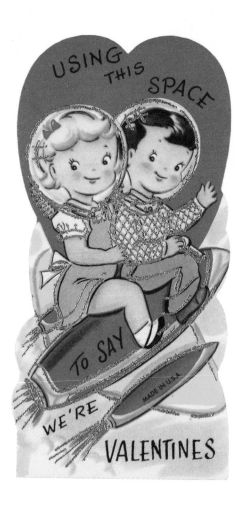

VALENTINES

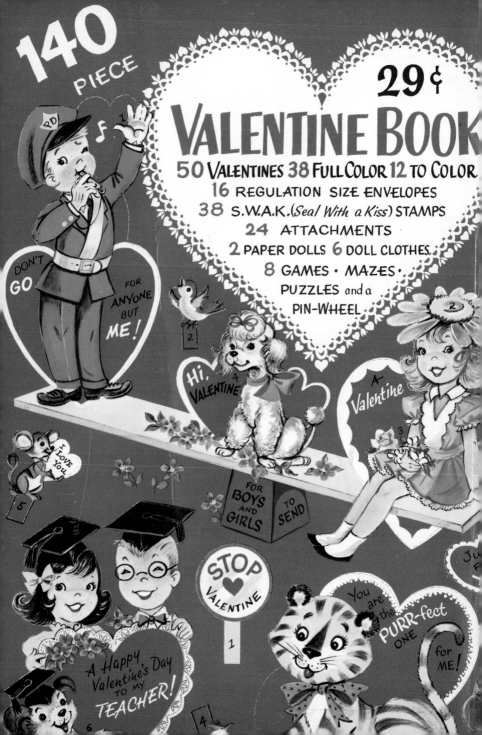

VALENTINES
VINTAGE HOLIDAY GRAPHICS

Ed. Jim Heimann

TASCHEN

KÖLN LONDON LOS ANGELES MADRID PARIS TOKYO

Seeing Red

by Steven Heller

I see red every Valentine's Day—and not just hearts and roses. What nerve! A holiday devoted to love that invariably causes guilt! Roman Emperor Claudius the Cruel is probably to blame. In third century AD, he prohibited his soldiers from marrying so they would be free from romantic entanglements and, therefore, more willing to fight Rome's bloody wars. As legend goes, Valentine's Day began as a pagan feast of the flesh in honor of Juno Februata, goddess of feverish love, and became a day of defiance when a rebellious Gnostic priest named Valentinus secretly performed marriages. From these passionate roots grew one of America's most commercial holidays, and a burden on the bank accounts of romantic souls (lest they suffer the consequences).

Yet the holiday was presumably born of good intentions. Even before the reign of Claudius, adolescent Roman boys and girls were routinely segregated from one another except on February 14, the eve of the feast of Lupercalia, which commemorated the god of fertility. A lottery was customarily held in which slips of paper bearing girls' names were drawn by eager boys. Their forced coupling lasted for the entire festival and often resulted in true and lasting love. Claudius's decree threw a wet blanket on such romance, so in AD 270 Valentinus took matters into his own hands and surreptitiously administered the sacrament of marriage. For his defiance he was imprisoned and executed, legend has it, on February 14.

In centuries that followed, the Catholic Church encouraged celebrants of this holy day to draw names of saints instead of lovers, and to emulate the chosen saints for an entire year—which was decidedly less fun than the rites of Lupercalia. To counter defections, the church agreed to institute a romantic ritual in St. Valentinus's name (though our priestly hero knew not about the matters of love). The church exaggerated his deeds to improve his chaste image. One tale goes that during his imprisonment, Valentinus cured his jailer's daughter of blindness, and she fell madly in love with him. On the eve of his fated beheading, Valentinus sent a message to the girl signed: "From your Valentine."

St. Valentine's Day was a big hit. Despite the church's spin on the story, the religious Valentinus was not the most romantic symbol, which is why Cupid became the holiday's principal trademark. The chubby cherub wasn't always the personification of cute—nor was he even Christian—but he did symbolize love. Originally Cupid was composited from Roman mythology as Venus's son, and from Greek mythology as Aphrodite's offspring, Eros. As the messenger of love and mating, his invisible arrows induced hopeless love in the pierced hearts of mortal and god alike. With his cheeky grin, Cupid was more appealing than even the saintliest saint. He was also a perfect trope for Victorian ornament, which accounts for his ubiquity on graphics from the nineteenth through the early twentieth centuries.

The first valentine missive, however, was free of cupids, cherubs, or hearts. It was in 1415 that an imprisoned Charles, Duke of Orléans, first wrote loving valentine verses from his jail cell to his wife. By the sixteenth century, syrupy epistles were commonplace. And by the end of the eighteenth century the earliest manufactured cards decorated with secular images were available. By the nineteenth, advances in chromolithographic printing and die cutting allowed for a wide variety of lavish cards decorated with lace, silk or satin, feathers, filigree, and gold leaf. The lexicon of valentine imagery on cards, magazine covers, wrapping papers, and advertisements was finally complete when the bulbous red heart became a universal sign of love. Today, valentines of all kinds are second only to Christmas greetings in terms of sales.

As cute and witty as valentines may be, they are designed to carry more emotive weight and exhibit more passion than other holiday greetings. "Be mine" is not just a benign slogan—it is a command performance. Valentine images may be tender and sweet, but all that red is really a vivid reminder that love is from the heart, even though the heart is easily broken.

Mir wird rot vor Augen

von Steven Heller

Jeden Valentinstag sehe ich rot – und nicht nur wegen der Herzen und Rosen. Was für eine Frechheit! Ein ganzer, der Liebe gewidmeter Feiertag, der unweigerlich zu Schuldgefühlen führt! Der römische Kaiser Claudius „der Grausame" ist wahrscheinlich schuld. Im dritten Jahrhundert n. Chr. verbot er seinen Soldaten die Eheschließung, damit sie frei von romantischen Banden williger waren, sich für Rom die Köpfe einschlagen zu lassen. Der Legende nach war der Valentinstag ursprünglich ein heidnisches Fest zu Ehren der Göttin Juno Februata, der „Göttin des Liebesfiebers", und wurde zu einem Tag des Widerstands, als der rebellisch gesinnte Bischof Valentin heimlich Trauungen vollzog. Aus diesen leidenschaftlichen Anfängen entwickelte sich einer der kommerziellsten aller amerikanischen Feiertage und eine Last für die Bankkonten romantisch veranlagter Seelen (um unangenehme Konsequenzen zu vermeiden).

Ursprünglich standen jedoch vermutlich gute Absichten hinter diesem Feiertag. Sogar schon vor der Herrschaft des Claudius wuchsen im alten Rom junge Männer und Mädchen getrennt voneinander auf und kamen nur am 14. Februar zusammen, dem Vorabend des Festes der Luperkalien zu Ehren der Fruchtbarkeitsgöttin Lupa. Es war Sitte, eine Art Lotterie durchzuführen, bei der Lose mit den Namen der Mädchen darauf von den Jungen gezogen wurden. Die so ausgelosten Paare blieben während der gesamten Feierlichkeiten zusammen, oft entwickelten sich daraus echte und anhaltende Liebesbeziehungen. Das Heiratsverbot des Claudius machte diesen romantischen Verhältnissen den Garaus, weswegen Bischof Valentin die Sache im Jahre 270 n. Chr. in die Hand nahm und unerlaubterweise die Ehesakramente spendete. Dafür wurde er der Legende zufolge ins Gefängnis geworfen und am 14. Februar hingerichtet.

In den folgenden Jahrhunderten rief die christliche Kirche dazu auf, an diesem Feiertag die Namen von Heiligen statt von Liebhabern zu ziehen und dem ausgelosten Heiligen ein ganzes Jahr lang nachzueifern – was wesentlich weniger Spaß machte als die Riten der Luperkalien. Um Meutereien vorzubeugen, erklärte die Kirche sich bereit, ein romantisches Fest im Namen des heiligen Valentin einzuführen (auch wenn unser priesterlicher Held wohl kaum eine Autorität in Liebesdingen war). Von kirchlicher Seite her wurden seine guten Taten in ein immer besseres Licht gestellt und sein keusches Image wurde entsprechend gesteigert. In einer Legende heißt es, dass der eingekerkerte Valentin die Tochter seines Wächters von der Blindheit heilte, woraufhin sie sich wahnsinnig in ihn verliebte. Am Abend vor der festgesetzten Enthauptung sandte Valentin dem Mädchen ein Briefchen mit der Unterschrift: „Von deinem Valentin".

Der Valentinstag entwickelte sich also zum großen Hit. Trotz der kirchlichen Umdeutung der Story war der Märtyrer Valentin nicht unbedingt das geborene

romantische Symbol, weswegen sich erst Cupido zum wahren Markenzeichen des Feiertages entwickelte. Der pausbäckige Cherub galt nicht immer als Niedlichkeit in Person, und christlich war er auch nicht, aber er war das Sinnbild der Liebe. Ursprünglich war Cupido eine Mischgestalt aus Amor, Sohn der Venus aus der römischen Mythologie, und Eros, Sohn der Göttin Aphrodite aus der griechischen Mythologie. Von den unsichtbaren Pfeilen des Liebesboten getroffen, entflammten die Herzen von Menschen wie Göttern in hoffnungslosem Verlangen. Mit seinem verschmitzten Grinsen war Cupido liebenswerter als selbst der Heiligste aller Heiligen. Für die viktorianische Ornamentik war er ein perfektes Motiv, was seine Allgegenwärtigkeit in Bildern und Grafiken vom 19. bis ins frühe 20. Jahrhundert hinein erklärt.

Die erste Grußbotschaft zum Valentinstag entbehrte jedoch jeglicher Cupidos, Cherubim und Herzchen. Im Jahre 1415 schrieb der im Gefängnis schmachtende Charles, Herzog von Orléans, aus der Gefängniszelle die erste Valentinskarte mit Liebesgedichten an seine Frau. Im 16. Jahrhundert waren zuckersüße Epistel bereits gang und gäbe. Und am Ende des 18. Jahrhunderts gab es schon die frühesten vorgefertigten Briefkarten mit weltlichen Motiven darauf. Die Fortschritte in der Farblithografie und beim Schneiden von Matrizen im 19. Jahrhundert ließen erstmals eine große Bandbreite üppiger Grußkarten entstehen, die mit Spitzen, Seidenbändern, Federn, Filigranarbeiten und Blattgold verziert waren. Das Lexikon des Bildschmucks zum Valentinstag, der nun auf Grußkarten, Zeitschriftencovern, Einwickelpapier und Anzeigen zu finden war, war endlich komplett, als das plastisch gewölbte rote Herz zum Universalsymbol der Liebe auserkoren wurde. In den USA werden heute fast so viele „Valentines" wie Weihnachtskarten verschickt.

So niedlich und witzig diese Valentinstagskarten auch sein mögen – in ihnen stecken mehr emotionales Gewicht und Leidenschaft als in den Grußbotschaften zu anderen Feiertagen. „Werde mein!" ist keine nette Floskel – das ist ein Befehl, der befolgt werden will! Die Bildchen zum Valentinstag mögen zärtlich und süß sein, aber in Wirklichkeit erinnert einen das viele Rot doch vor allem an eins: Dass Liebe von Herzen kommt und Herzen nur zu leicht gebrochen werden.

Voir rouge

par Steven Heller

Je vois rouge à chaque Saint-Valentin – et pas seulement des cœurs et des roses. Quel culot ! Un jour de fête consacré à l'amour qui vous culpabilise à chaque fois ! L'empereur romain Claude le Cruel est probablement à blâmer. Au IIIe siècle avant J.-C., il interdit à ses soldats de se marier pour qu'ils soient libres de tout engagement et donc plus disposés à aller se battre dans des campagnes militaires sanglantes pour défendre Rome. D'après la légende, la Saint-Valentin était à l'origine une fête païenne, une fête de la chair à la gloire de Juno Februata, la déesse de l'amour ardent, qui devint un jour de provocation lorsqu'un prêtre gnostique rebelle, Valentin, commença à marier secrètement les couples. De ces origines passionnées est issue l'une des fêtes les plus commerciales de l'Amérique et un fardeau pour les comptes en banque des âmes romantiques (par peur d'en avoir à en subir les conséquences).

Et pourtant la fête avait probablement été instituée avec les meilleures intentions. Bien avant le règne de Claudius, les Romains séparaient habituellement les garçons et les filles adolescents, excepté le 14 février, la veille des Lupercales – des festivités données en l'honneur du dieu de la fertilité. La coutume voulait qu'une loterie soit organisée, au cours de laquelle les jeunes hommes impatients tiraient au sort des bouts de papier sur lesquels les noms des jeunes filles étaient inscrits. Cet engagement forcé durait jusqu'à la fin des festivités et se transformait souvent en un véritable amour durable. Le décret de Claudius fit l'effet d'une douche froide sur ces romances, ce qui poussa, en 270 avant J.-C., Valentin à remédier à la situation en administrant secrètement les sacrements du mariage. Pour cet acte de révolte, il fut emprisonné et exécuté, d'après la légende, un 14 février.

Dans les siècles qui suivirent, l'Église catholique incita les participants à la fête à inscrire des noms de saints au lieu de ceux des jeunes filles et de suivre l'exemple du saint assigné pendant une année entière – ce qui était vraiment moins amusant que les rites des Lupercales. Pour prévenir les défections, l'Église accepta d'instituer un rituel romantique en l'honneur de saint Valentin (bien que notre héros ne connaisse rien aux histoires d'amour). L'Église exagéra ses bienfaits pour confirmer sa réputation de chasteté. Une histoire raconte que pendant son emprisonnement, Valentin guérit la fille de son geôlier de la cécité et qu'elle tomba follement amoureuse de lui. La veille de sa décapitation, Valentin envoya un message à la demoiselle signé : « De votre Valentin ».

La Saint-Valentin connut un immense succès. En dépit de la récupération de l'histoire par l'Église, le pieux Valentin n'était pas ce qu'il y avait de plus romantique comme symbole, ce qui explique pourquoi Cupidon fut choisi comme l'emblème de cette fête. Le chérubin joufflu n'avait pas été toujours si adorable – il n'était même pas chrétien – mais il symbolisait l'amour. À l'origine, Cupidon était le fils de Vénus dans la mythologie romaine et celui d'Aphrodite, Éros, dans la mythologie grecque.

Messager de l'amour et du mariage, il décochait des flèches invisibles dans le cœur des hommes et des dieux pour leur inspirer un amour désespéré. Avec son sourire moqueur, Cupidon était quand même plus attrayant que le plus saint des saints. Il était aussi parfait comme symbole décoratif à l'ère victorienne, ce qui explique son omniprésence dans les tableaux du XIXe siècle jusqu'au début du XXe.

Pourtant, il n'y avait ni Cupidon, ni chérubin, ni cœur sur la première épître de la Saint-Valentin. En 1415 Charles, duc d'Orléans, fut le premier à envoyer, de sa prison, un poème d'amour à sa femme pour la Saint-Valentin. Au XVIe siècle, les épistoles doucereuses étaient devenues banales. C'est vers la fin du XVIIIe que sont apparues les premières cartes imprimées décorées d'images séculaires. Au XIXe siècle, les progrès de l'impression en chromolithographie et du découpage à la machine ont permis de fabriquer une grande diversité de cartes somptueuses ornées de dentelle, de soie ou de satin, de plumes, de filigrane et de feuille d'or. Le lexique du langage imagé de la Saint-Valentin sur les cartes, les couvertures de magazines, les papiers d'emballage et la publicité, a finalement été complet lorsque le cœur rouge et bombé est devenu le symbole universel de l'amour. De nos jours, les différentes sortes de Valentines viennent en seconde place après les vœux de Noël en chiffres de vente.

Aussi jolies et amusantes que soient les Valentines, elles sont plus faites pour émouvoir et témoigner de sa passion que les autres cartes de vœux. « Sois mienne » n'est pas seulement une petite phrase anodine – c'est une injonction. Les images des Valentines sont peut-être charmantes et attendrissantes, mais tout ce rouge est là pour nous rappeler haut et fort que l'amour vient du cœur, quoique ce cœur puisse facilement être brisé.

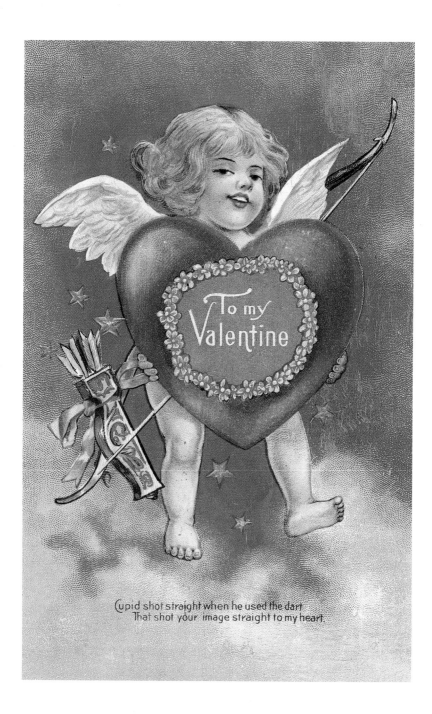

Cupid shot straight when he used the dart
That shot your image straight to my heart.

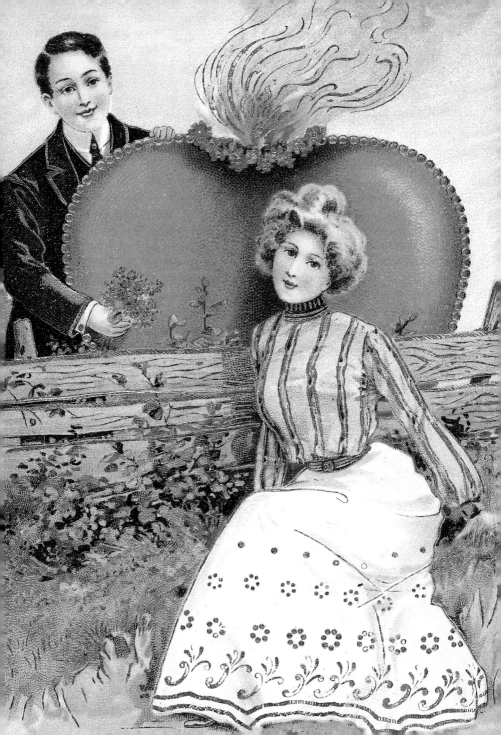

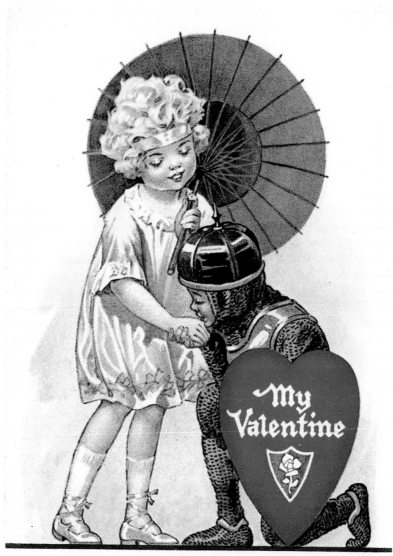

Just imagine I'm a knight,
 And you, my lady fair,
I'd take you over the hills away
 To my castle old and rare.

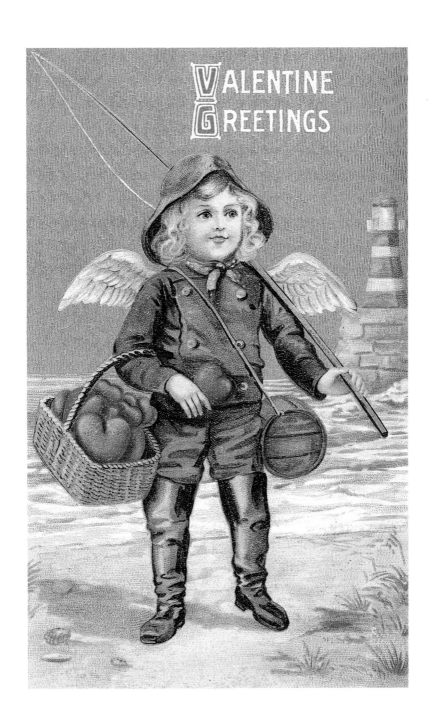

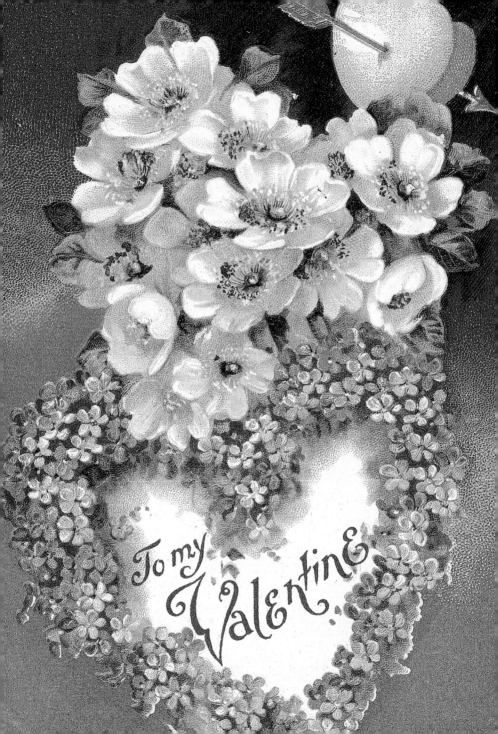

To my Valentine

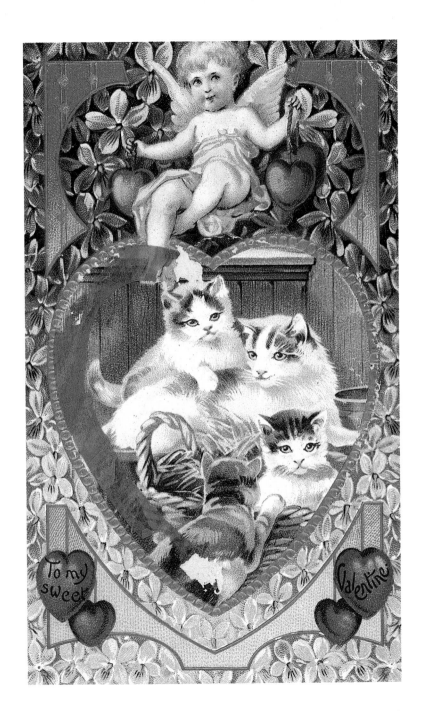

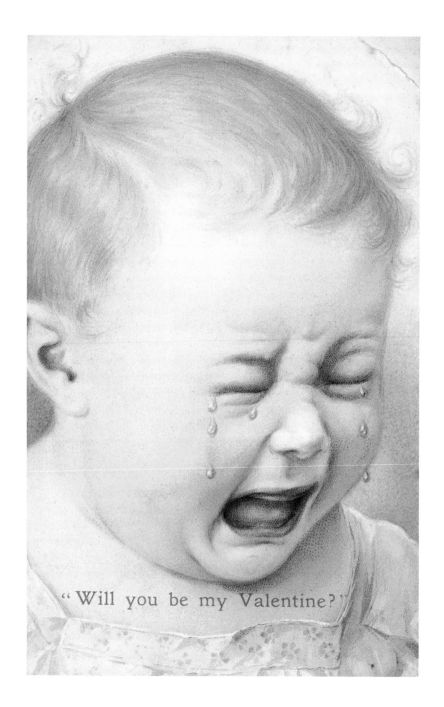

"Will you be my Valentine?"

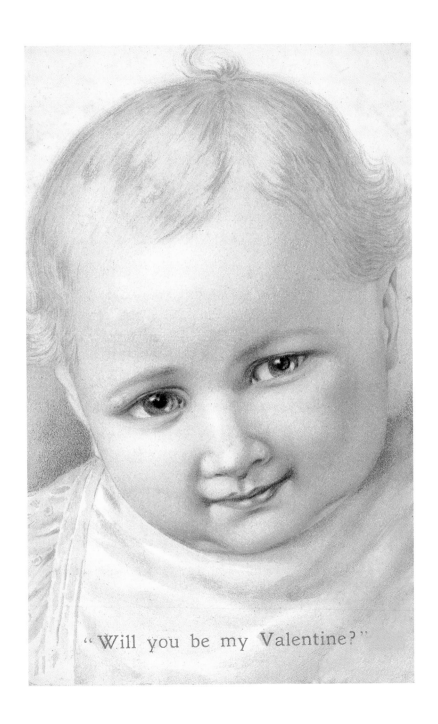

"Will you be my Valentine?"

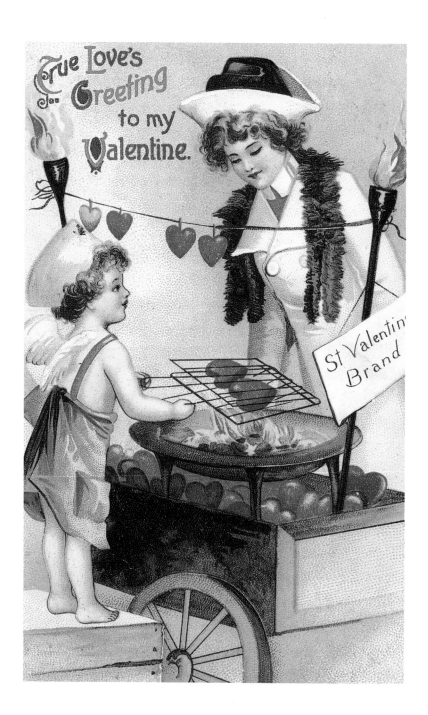

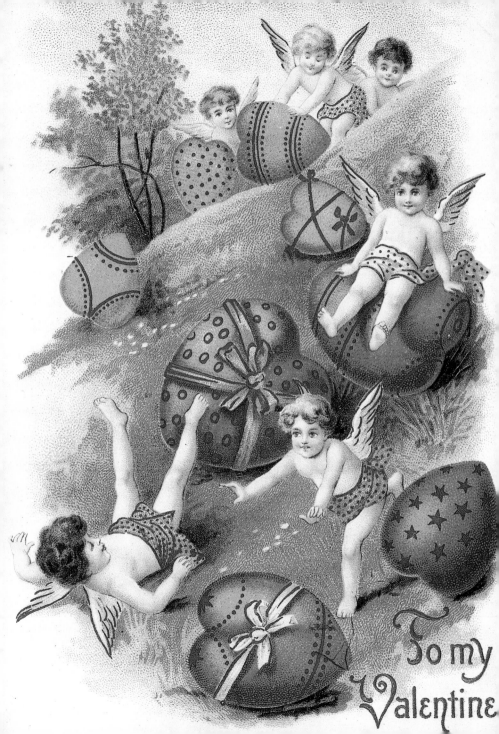

To my Valentine

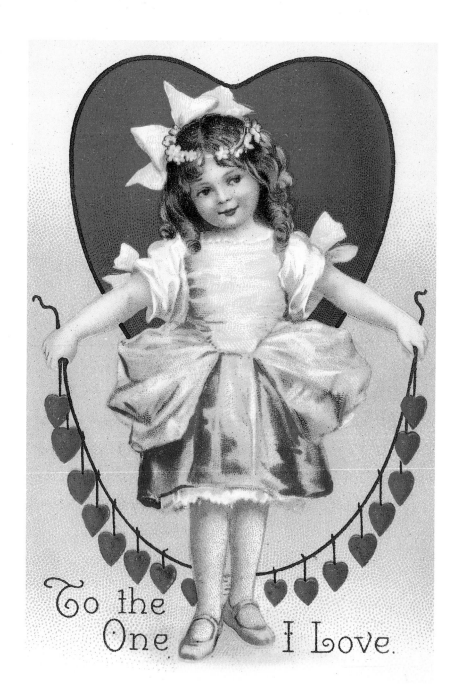

To the
One I Love.

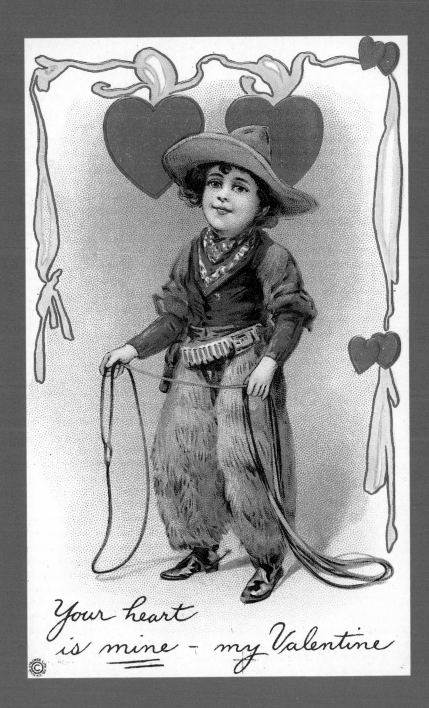

Your heart is mine — my Valentine

21

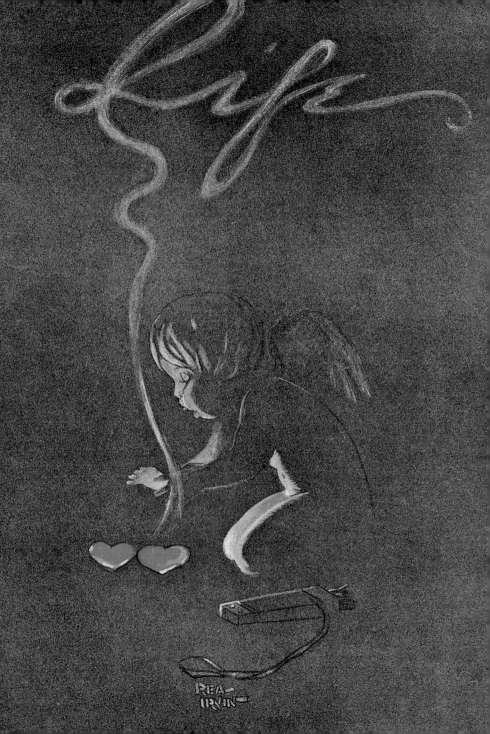

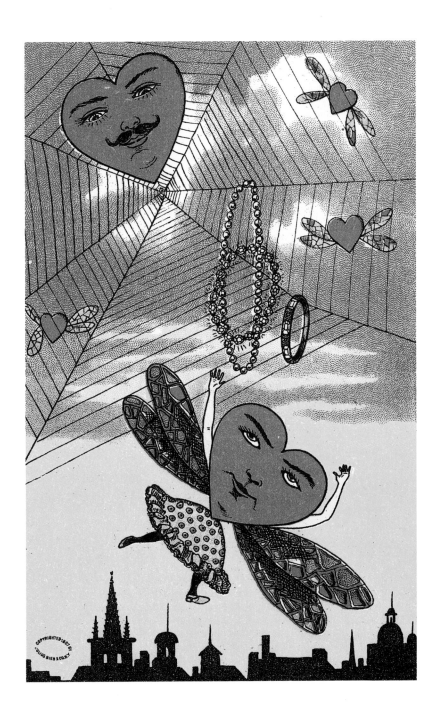

23

HONEY, HOW YOUR EYES DO SHINE!
WON'T YOU BE MY VALENTINE?
LET MY ARMS AROUND YOU TWINE,
LIKE THE CLINGING MELON VINE!

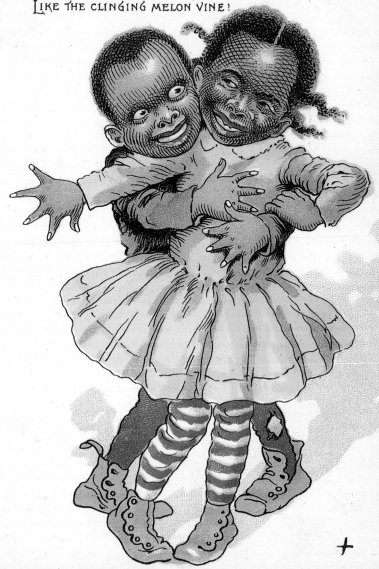

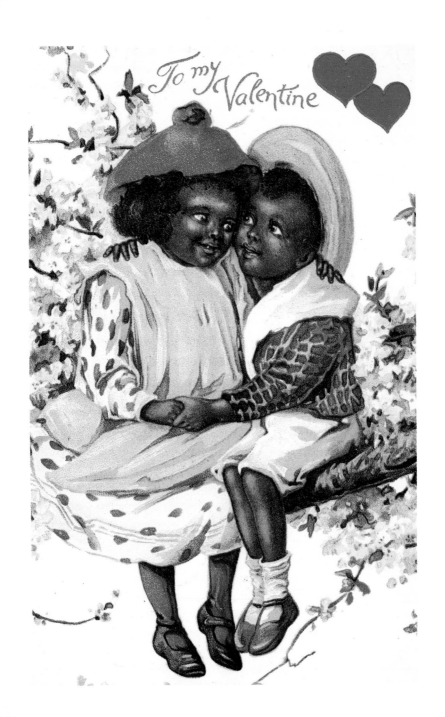

To my Valentine

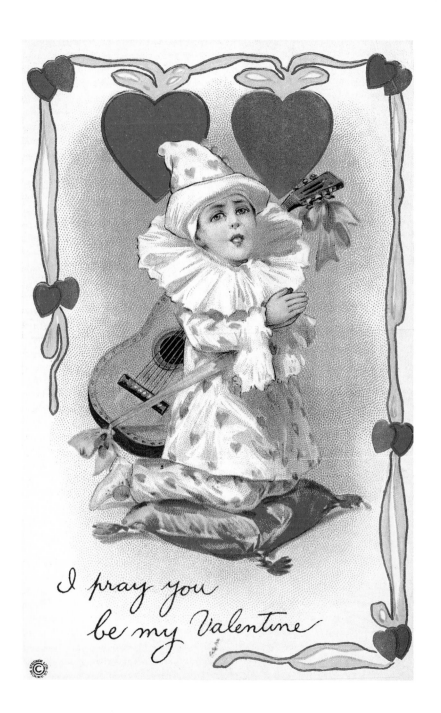

I pray you be my Valentine

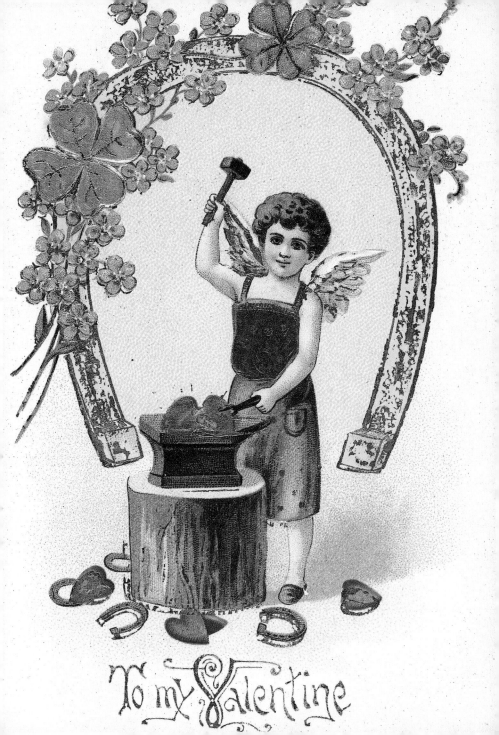

To my Valentine

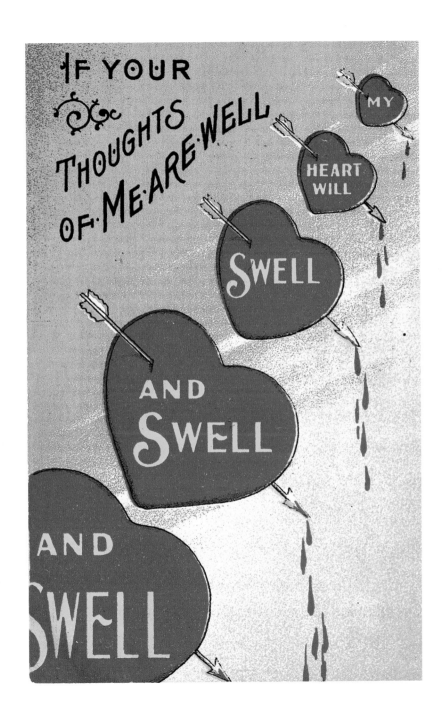

IF YOUR

THOUGHTS

OF·ME·ARE·WELL

MY

HEART WILL

SWELL

AND SWELL

AND SWELL

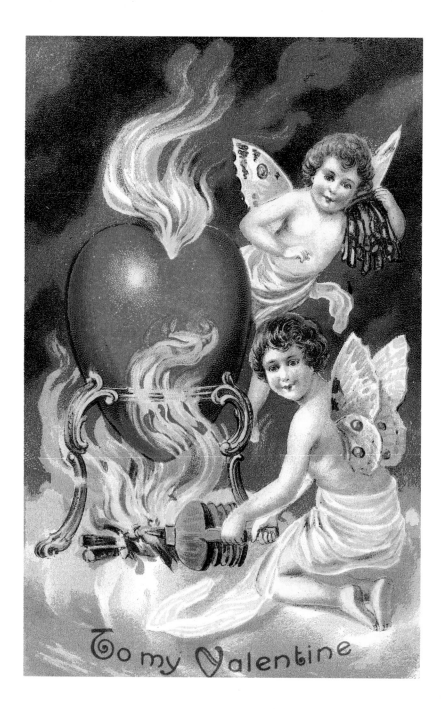

To my Valentine

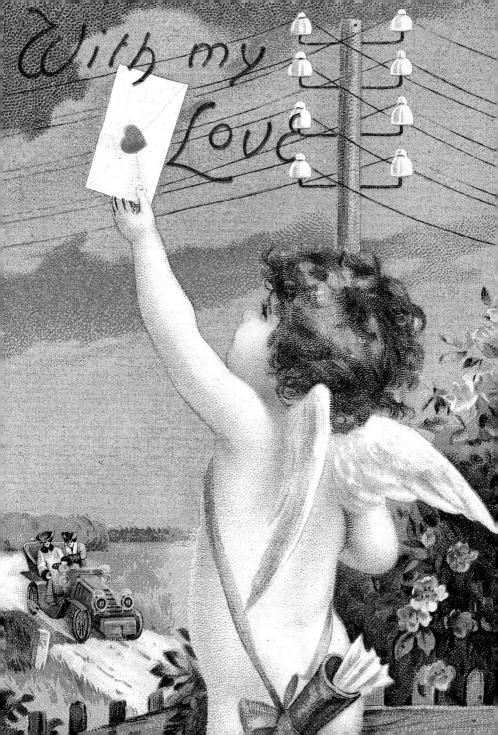

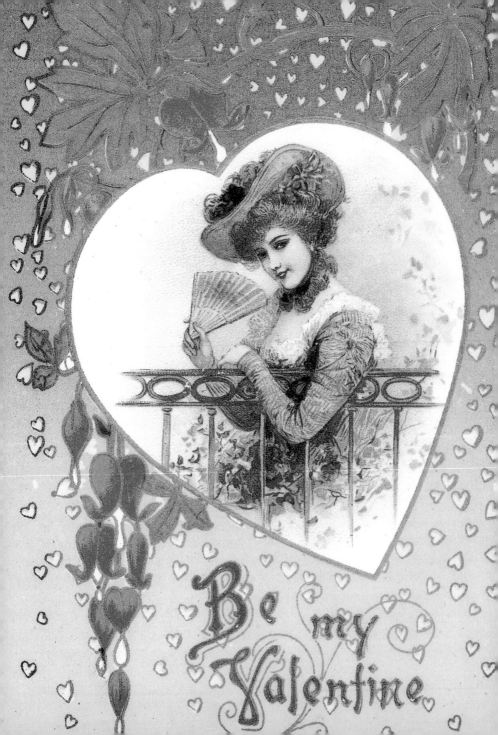

Be my
Valentine

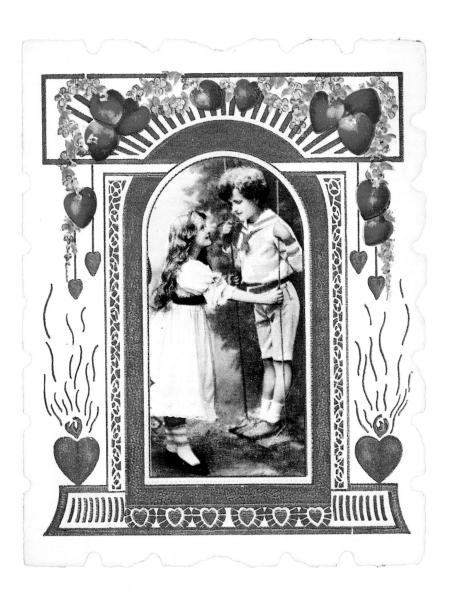

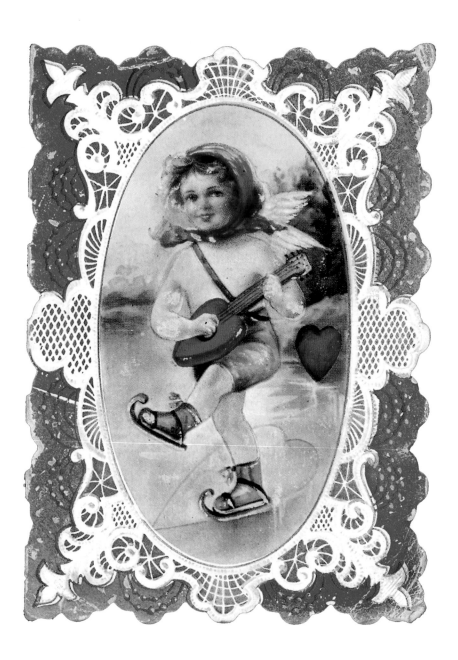

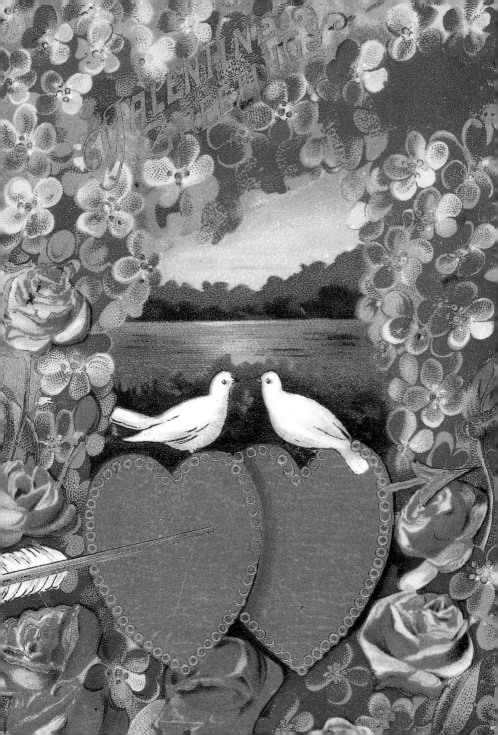

Valentine Greetings

VALENTINE GREETINGS

Love's
Fair Exchange.

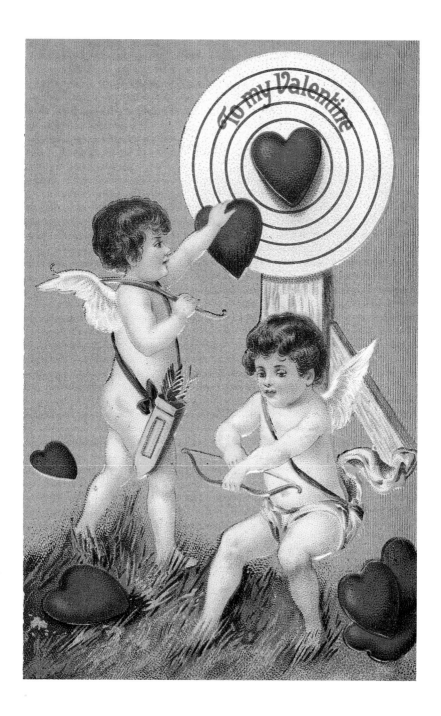

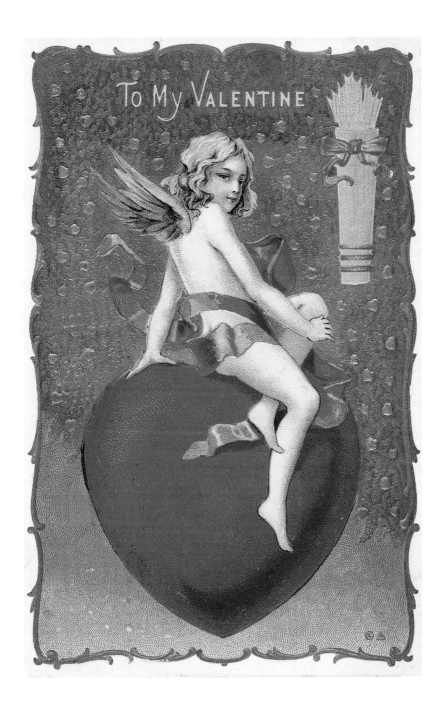

41

THE LADIES' HOME JOURNAL

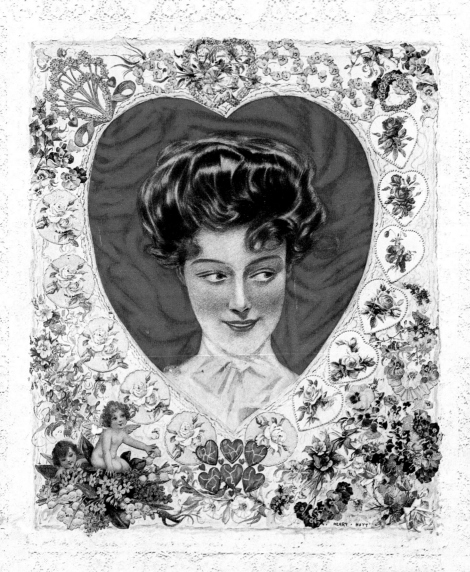

HENRY HUTT

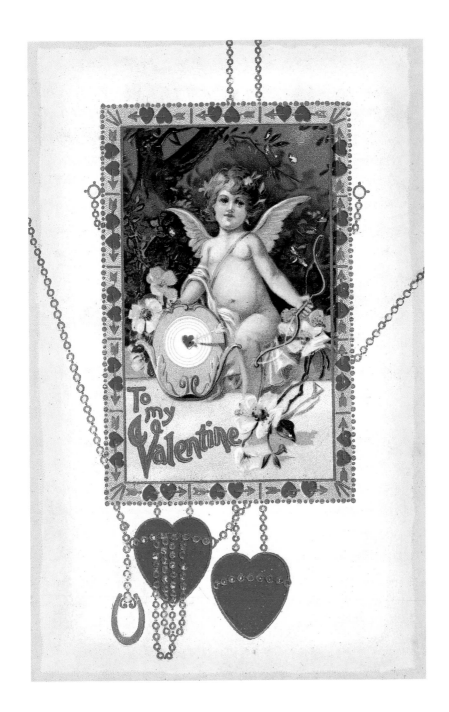

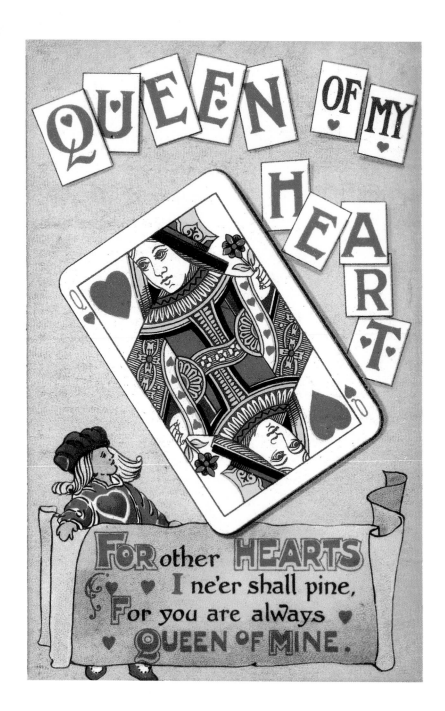

QUEEN OF MY HEART

FOR other HEARTS
I ne'er shall pine,
For you are always
QUEEN OF MINE.

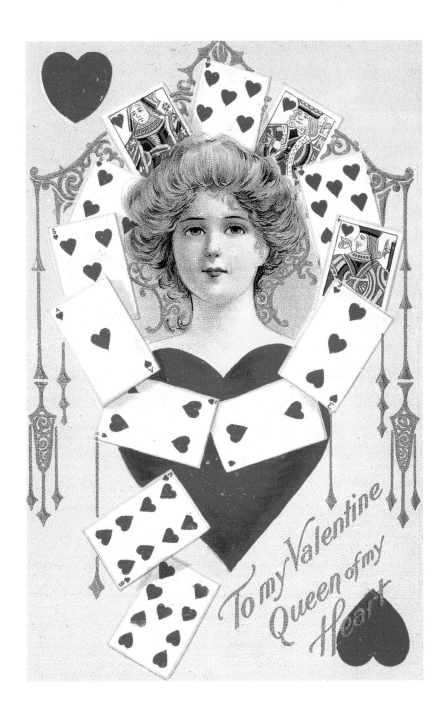

To my Valentine Queen of my Heart

45

Woman's Home Companion

February 1926

Fifteen Cents

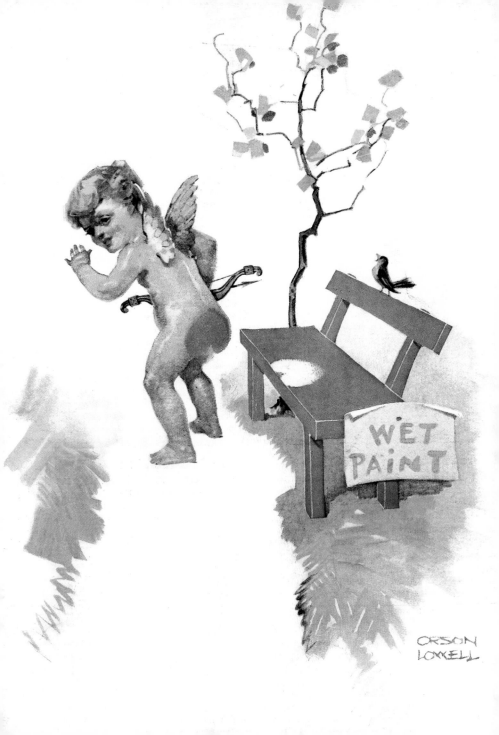

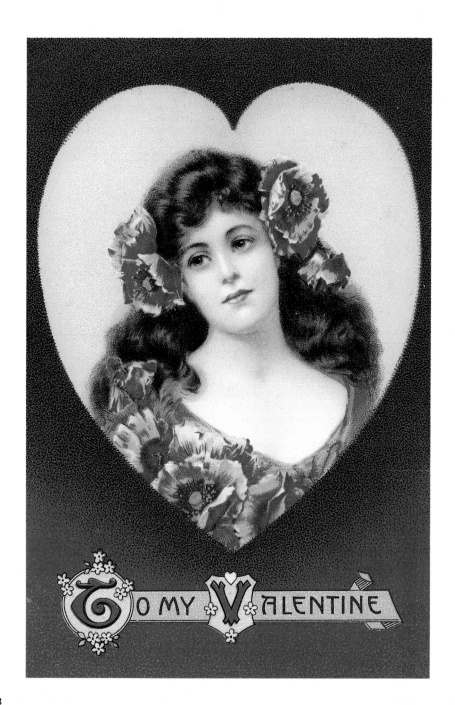

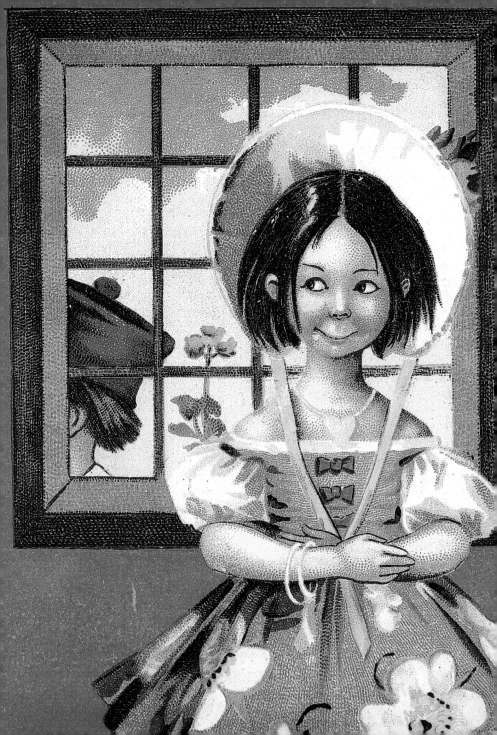

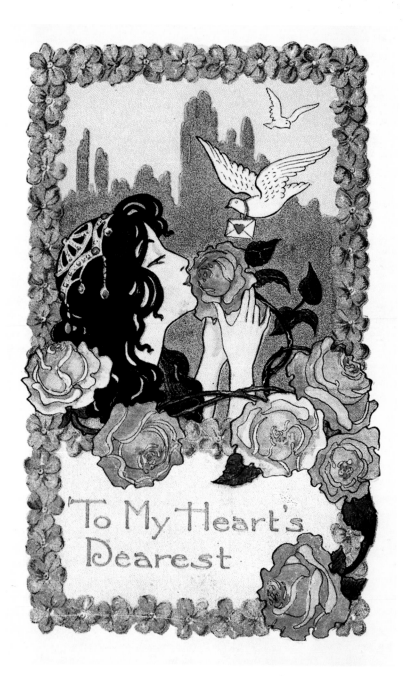

To My Heart's Dearest

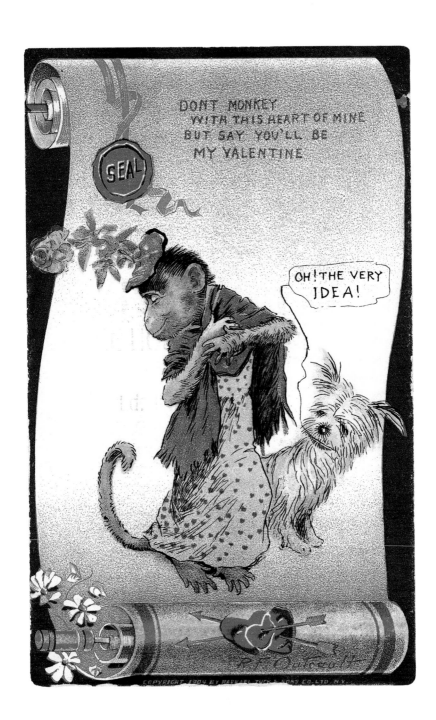

THE LADIES'
HOME JOURNAL

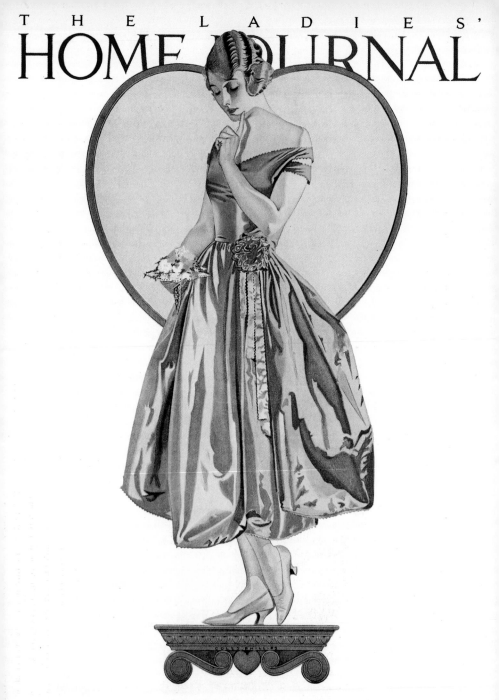

FEBRUARY 1921 THE CURTIS PUBLISHING COMPANY PHILADELPHIA. 20 CENTS By subscription $2.00 · In Canada, 25 cents; by subscription, $2.50

Volume XXXVIII, Number 2, published monthly at Philadelphia, entered as second class matter Nov. 6, 1911, at the Post Office at Philadelphia. Additional entry at Columbus, Ohio, under the act of Nov. 3, 1879.

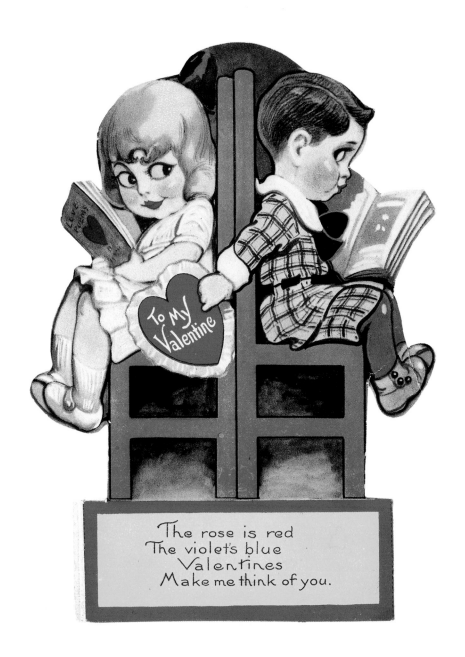

The rose is red
The violet's blue
Valentines
Make me think of you.

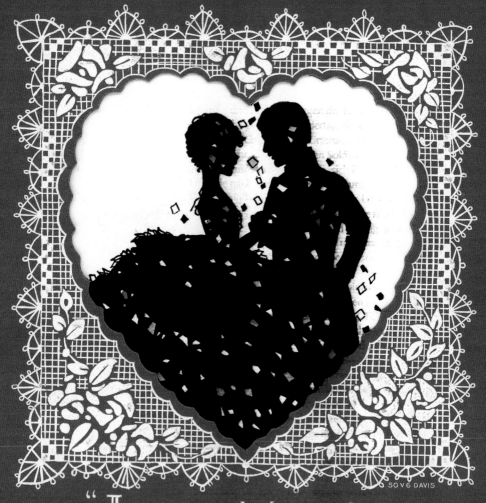

"JUST·FOR·YOUR·OWN
DEAR·SELF·ALONE"

THE DELINEATOR

FEBRUARY 1923

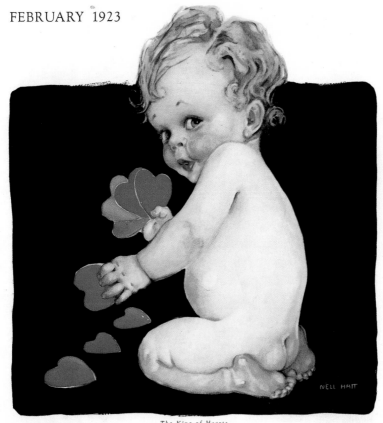

The King of Hearts

Beginning a new serial novel by

KATHLEEN NORRIS

A FORECAST OF SPRING FASHIONS

TWENTY CENTS THE COPY THE BUTTERICK PUBLISHING COMPANY, NEW YORK $2.00 A YEAR—$2.50 IN CANADA

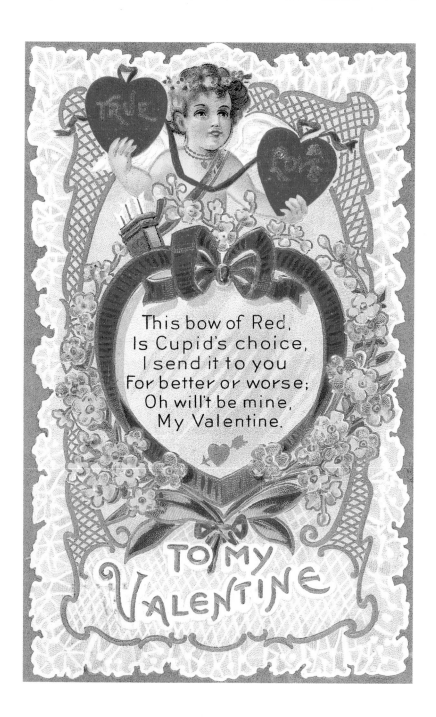

This bow of Red,
Is Cupid's choice,
I send it to you
For better or worse;
Oh will't be mine,
My Valentine.

TO MY
VALENTINE

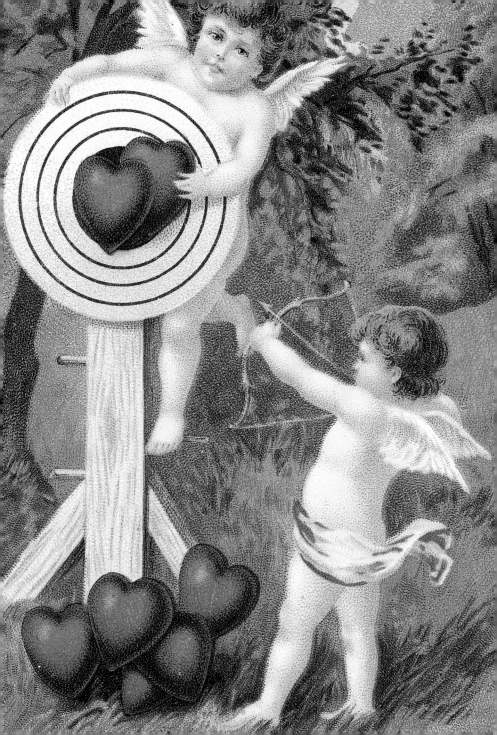

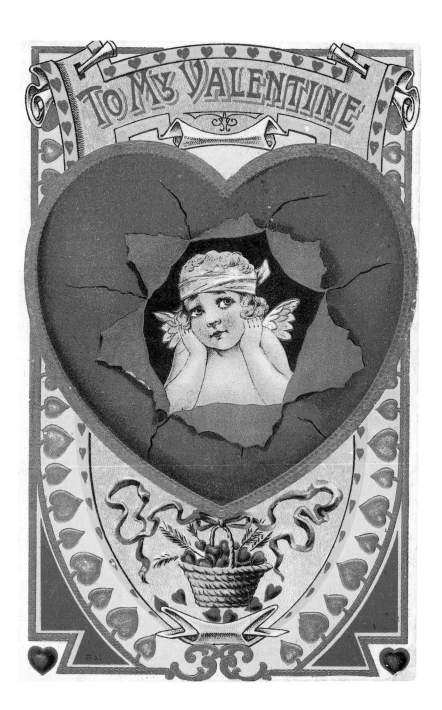

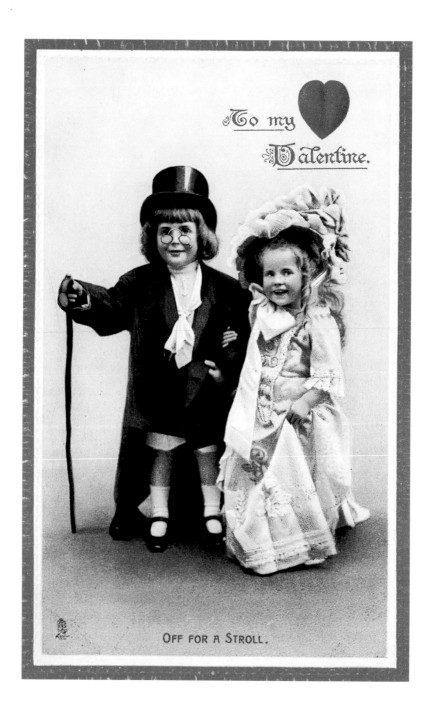

To my ♥ Valentine.

OFF FOR A STROLL.

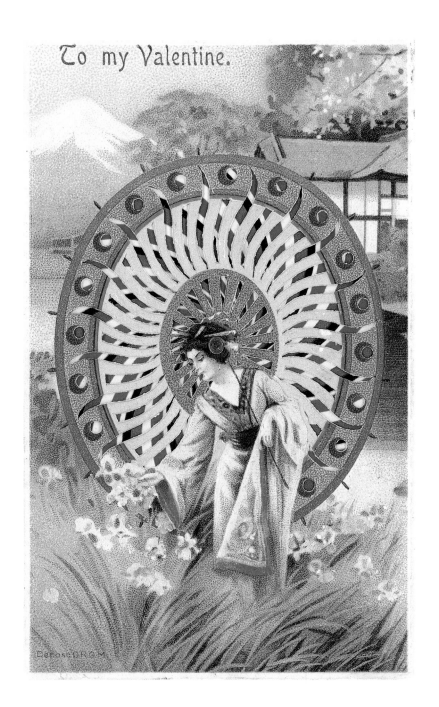

To my Valentine.

THE LADIES' HOME JOURNAL

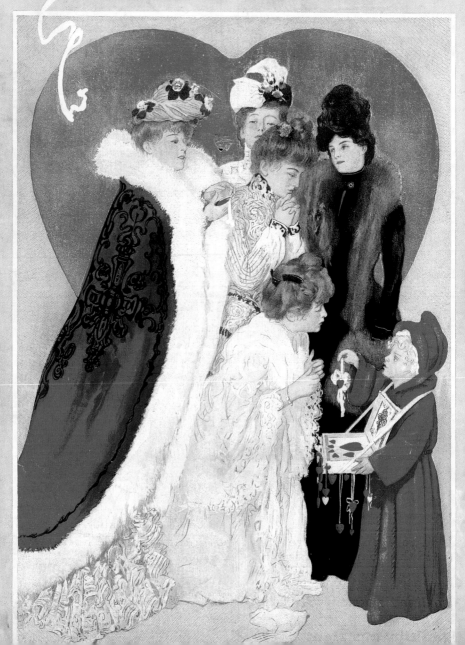

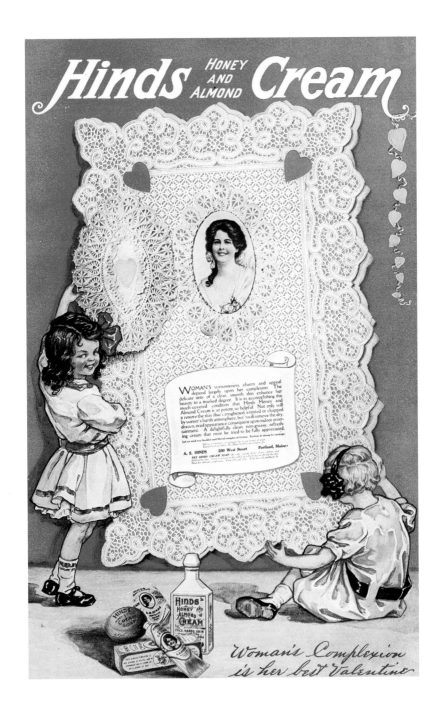

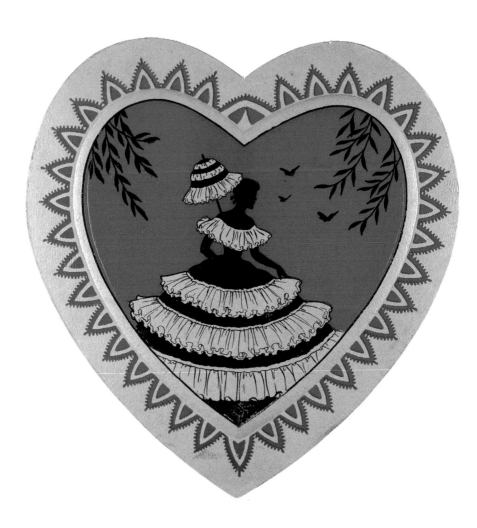

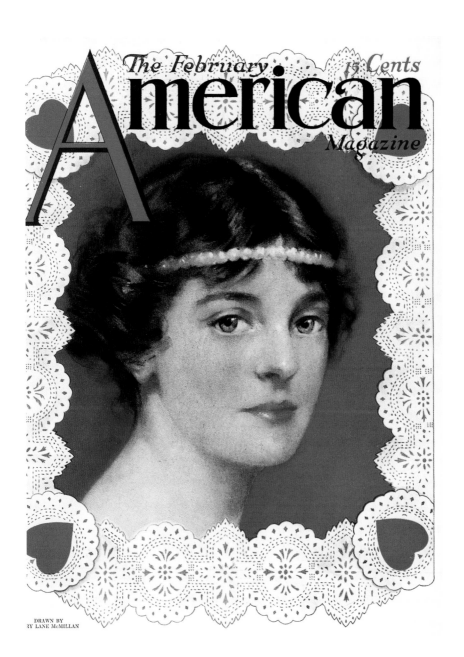

The February

15 Cents

American

Magazine

DRAWN BY
BY LANE McMILLAN

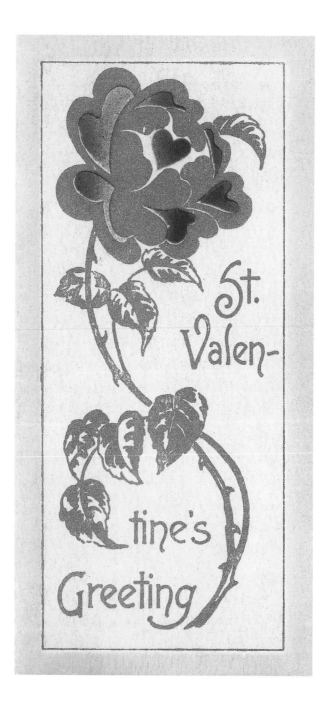

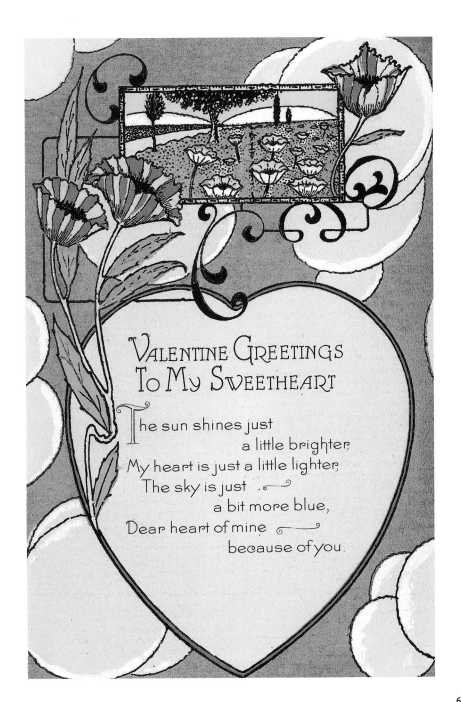

VALENTINE GREETINGS
TO MY SWEETHEART

The sun shines just
 a little brighter,
My heart is just a little lighter,
The sky is just
 a bit more blue,
Dear heart of mine
 because of you.

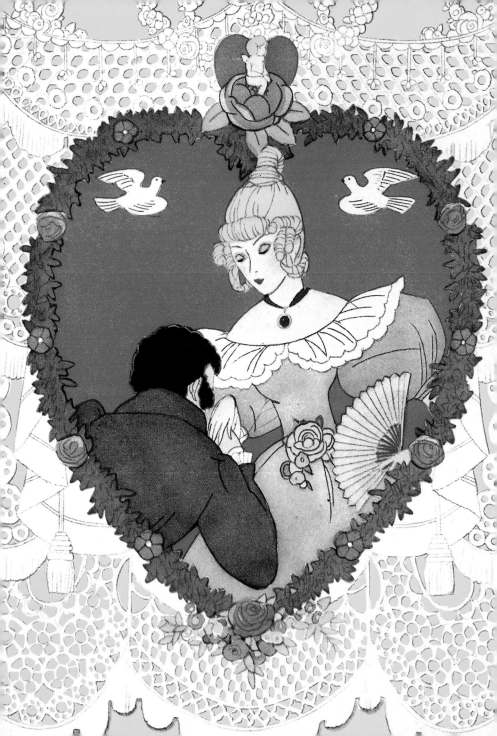

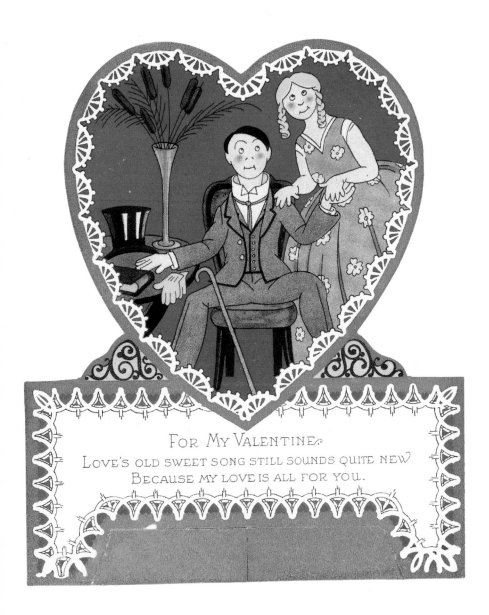

FOR MY VALENTINE
LOVE'S OLD SWEET SONG STILL SOUNDS QUITE NEW
BECAUSE MY LOVE IS ALL FOR YOU.

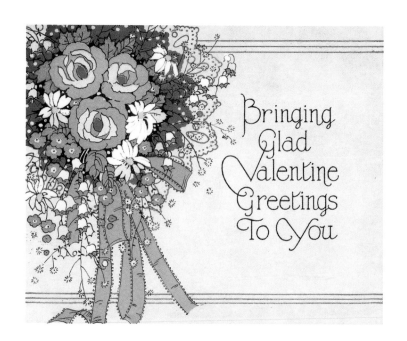

Bringing
Glad
Valentine
Greetings
To You

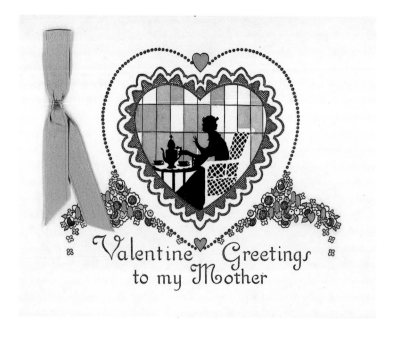

Valentine Greetings
to my Mother

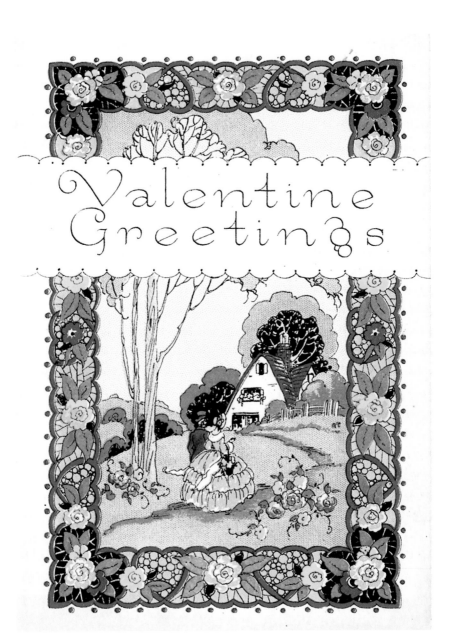

Valentine Greetings

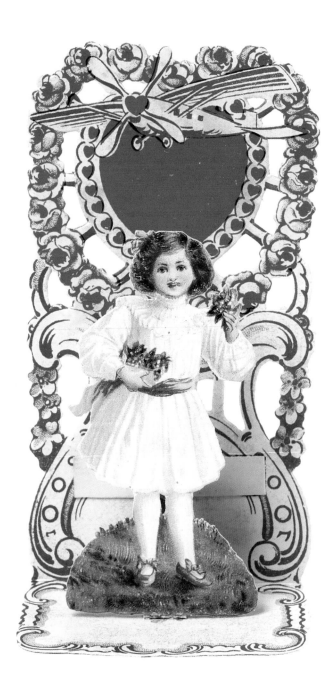

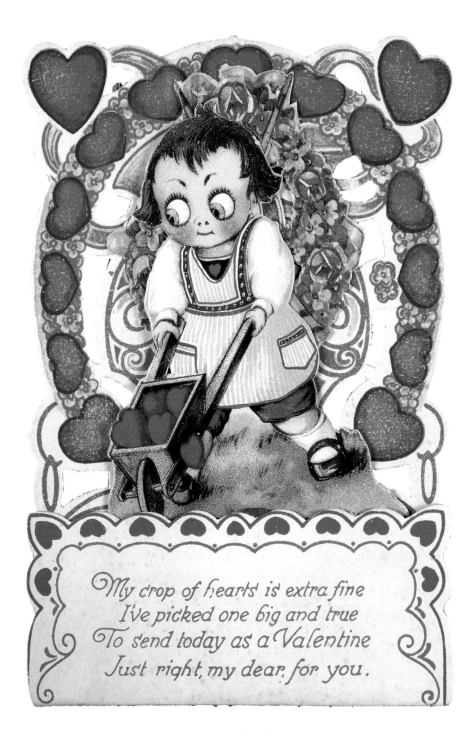

My crop of hearts is extra fine
I've picked one big and true
To send today as a Valentine
Just right, my dear, for you.

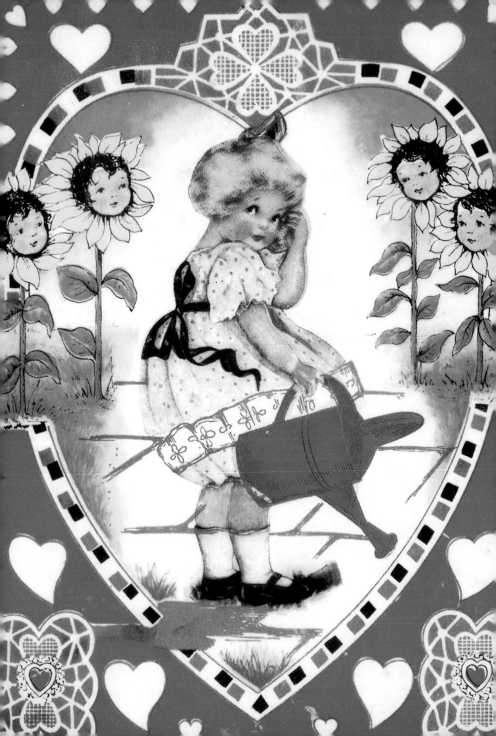

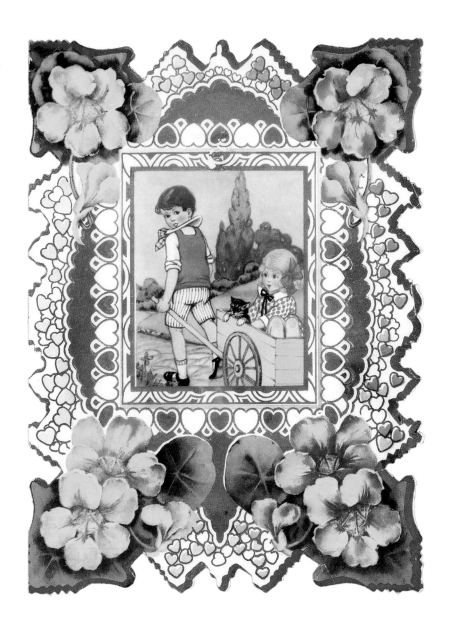

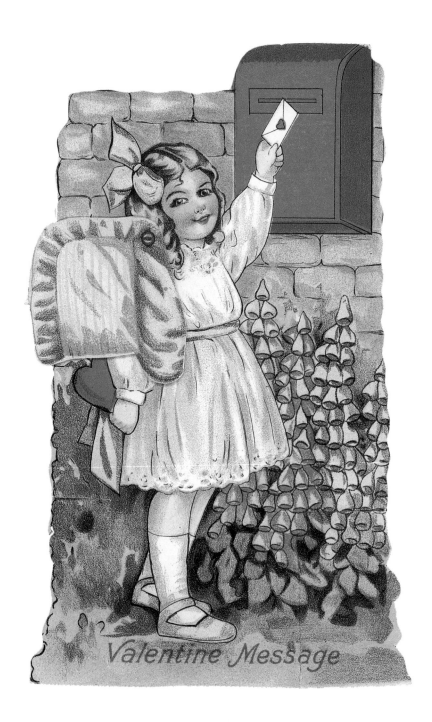

Valentine Message

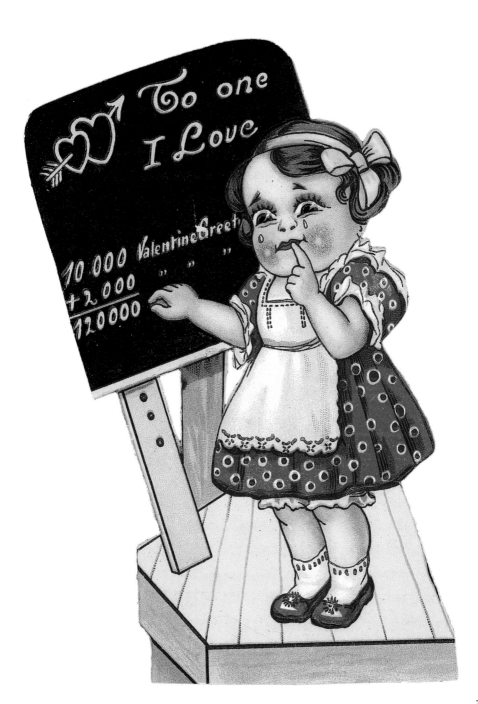

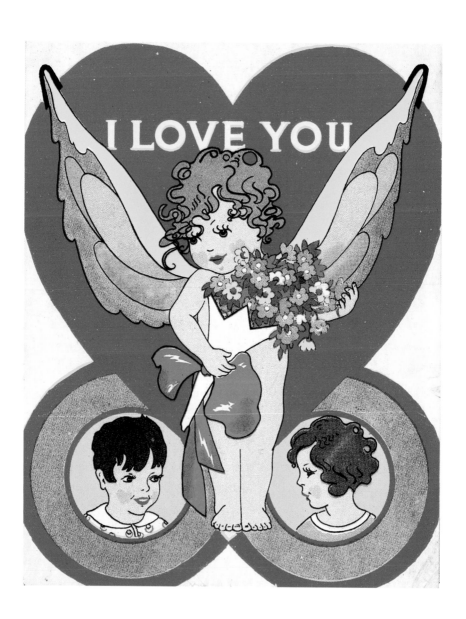

I LOVE YOU

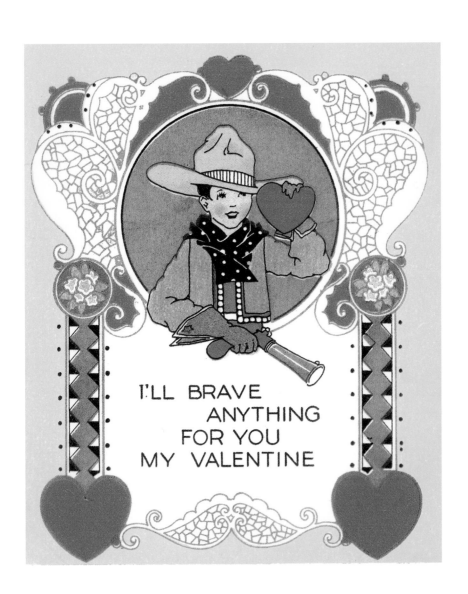

I'LL BRAVE
ANYTHING
FOR YOU
MY VALENTINE

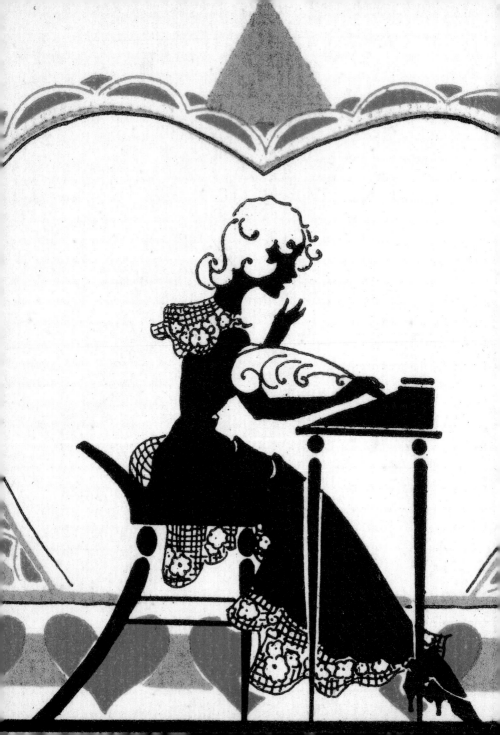

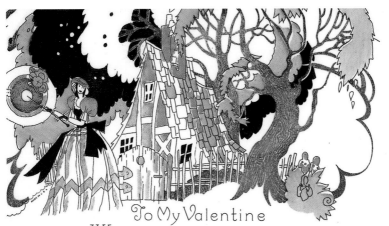

To My Valentine
With every wind that blows today
My loving thoughts will blow your way

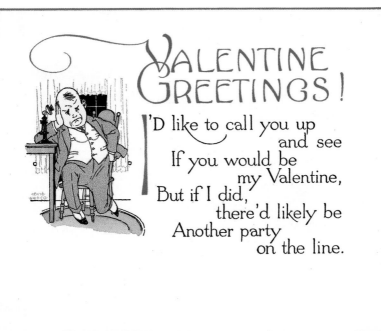

VALENTINE GREETINGS!

I'D like to call you up
 and see
If you would be
 my Valentine,
But if I did,
 there'd likely be
Another party
 on the line.

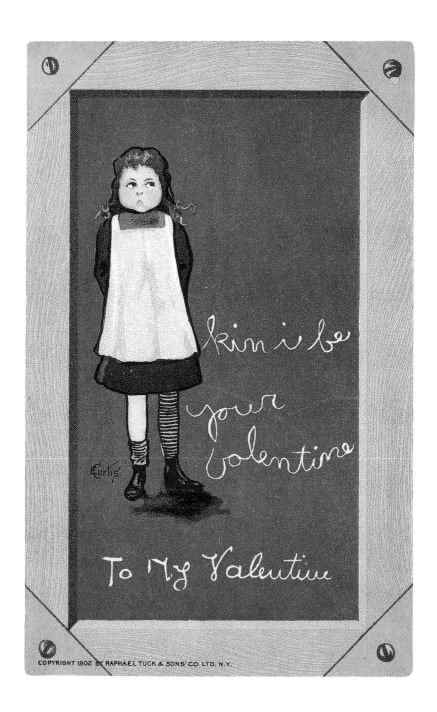

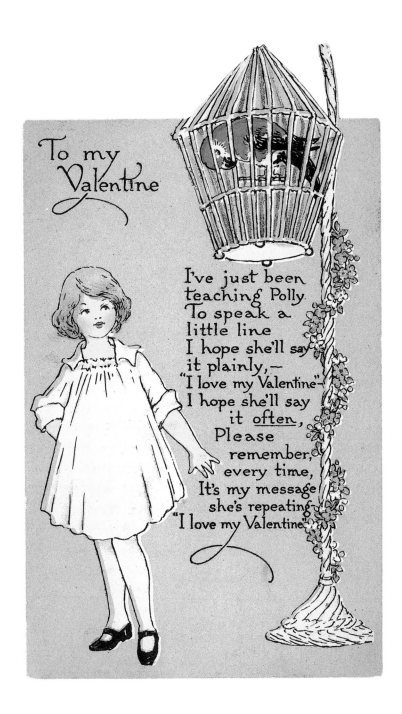

To my
Valentine

I've just been
teaching Polly
To speak a
little line
I hope she'll say
it plainly,—
"I love my Valentine"
I hope she'll say
it _often_,
Please
remember,
every time,
It's my message
she's repeating
"I love my Valentine"

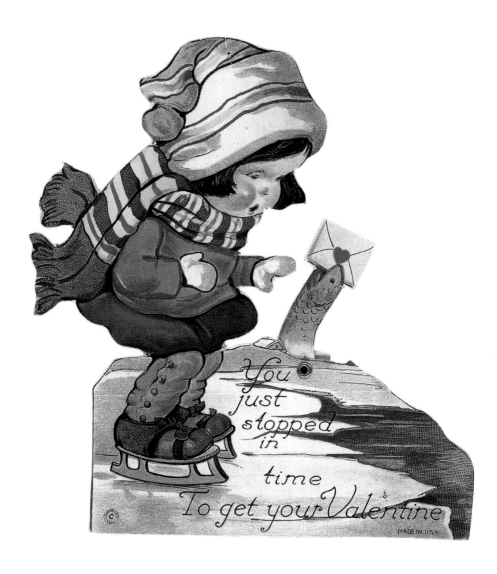

You
just
stopped
in
time
To get your Valentine

MADE IN U.S.A.

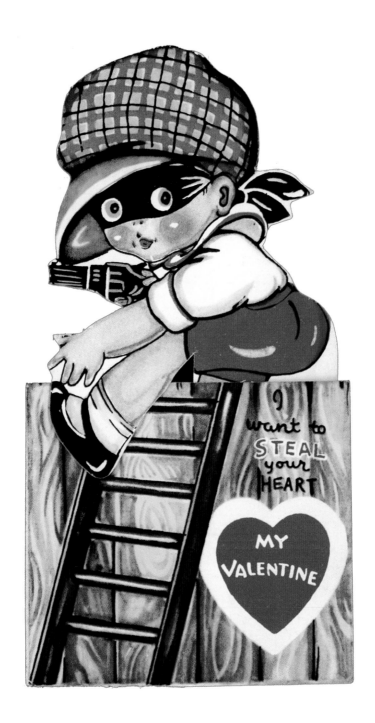

I want to STEAL your HEART

MY VALENTINE

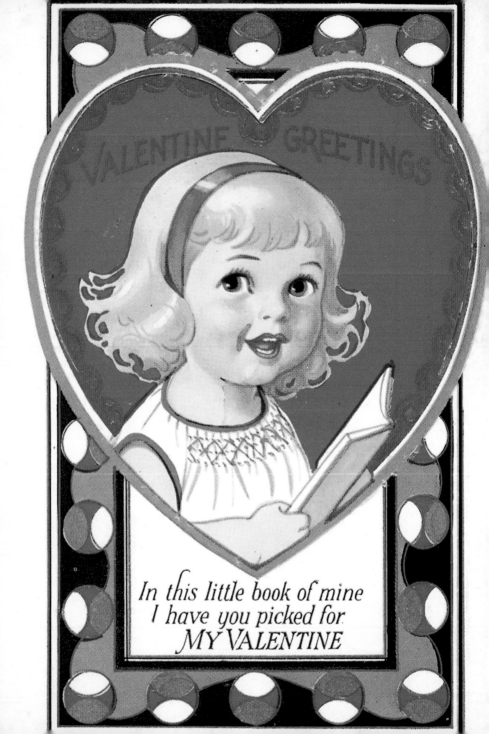

VALENTINE GREETINGS

In this little book of mine
I have you picked for
MY VALENTINE

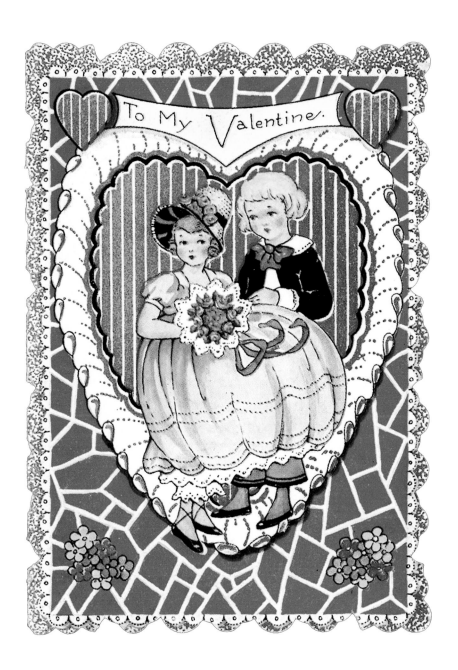

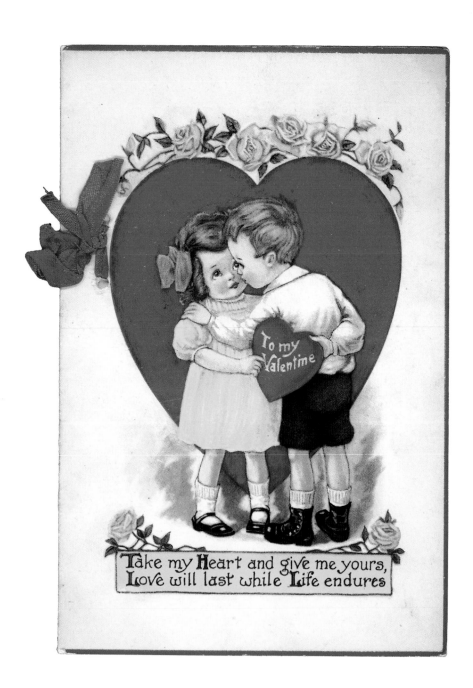

To my
Valentime

Take my Heart and give me yours,
Love will last while Life endures

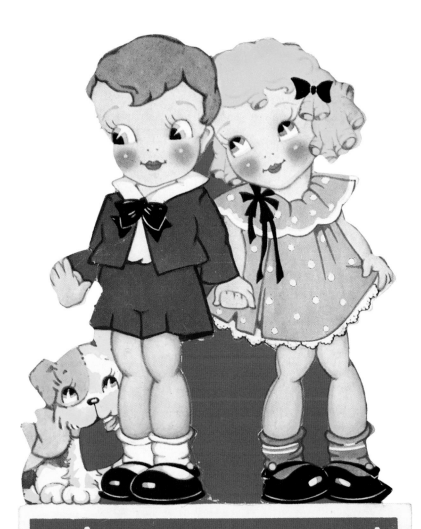

TWO'S COMPANY BUT THREE'S
A CROWD MY VALENTINE

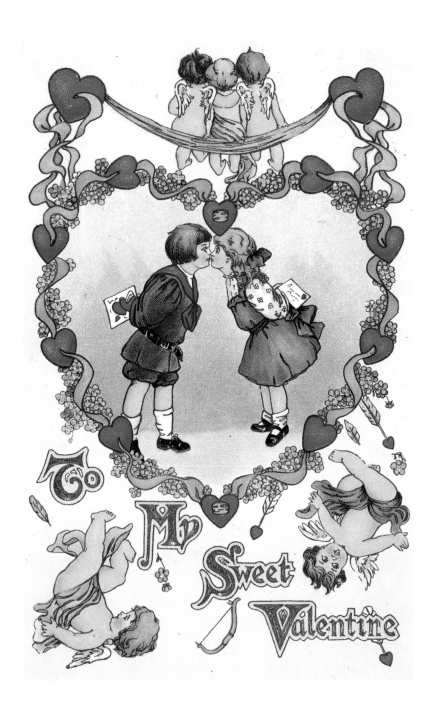

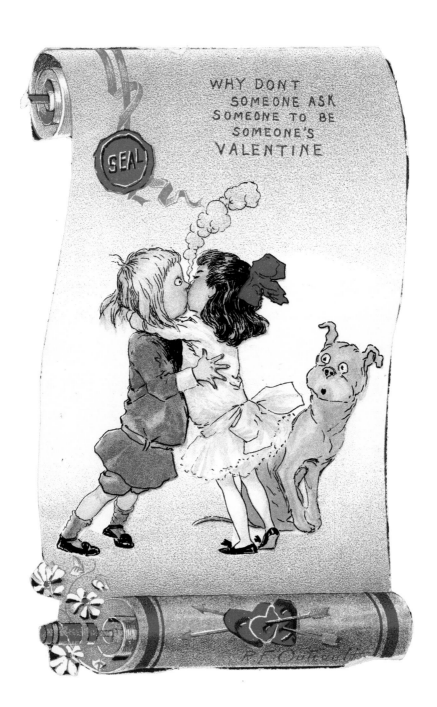

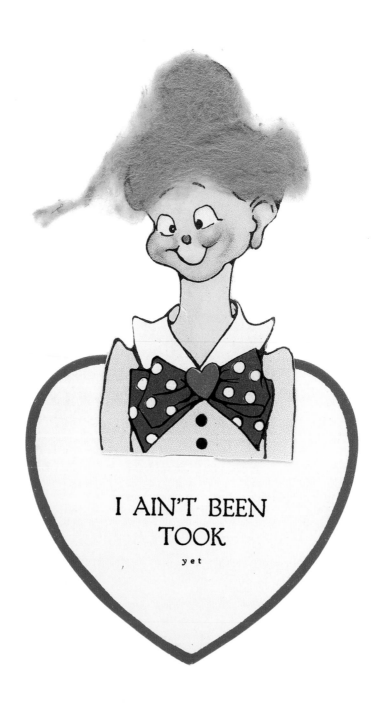

I AIN'T BEEN
TOOK

yet

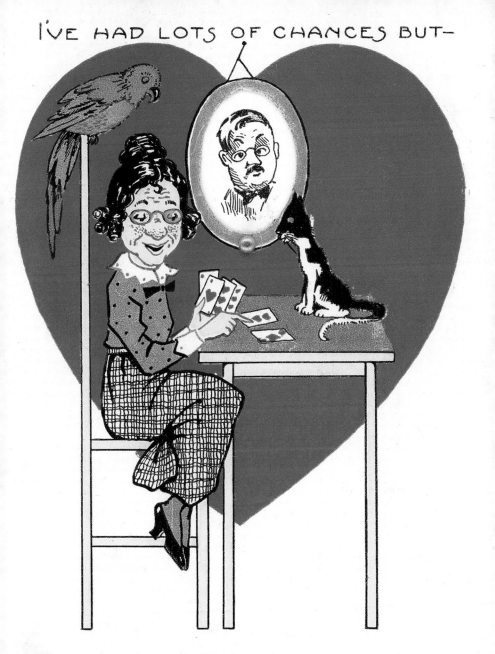

THE SATURDAY EVENING POST

5 cts.

10c. in Canada

FEB. 16 19

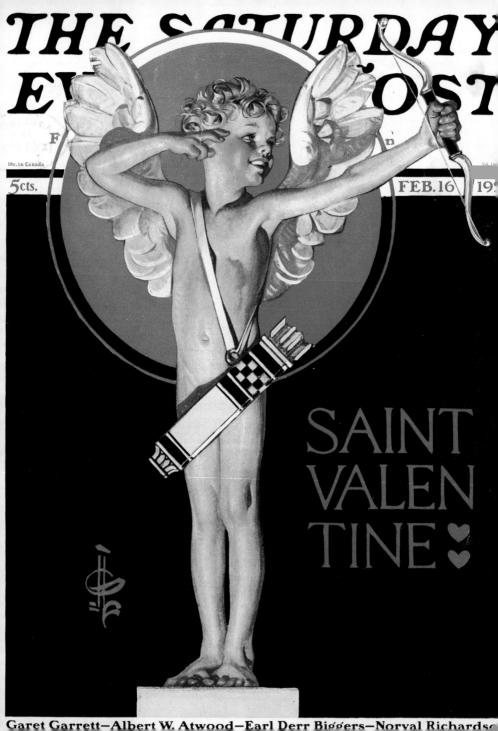

SAINT
VALEN
TINE

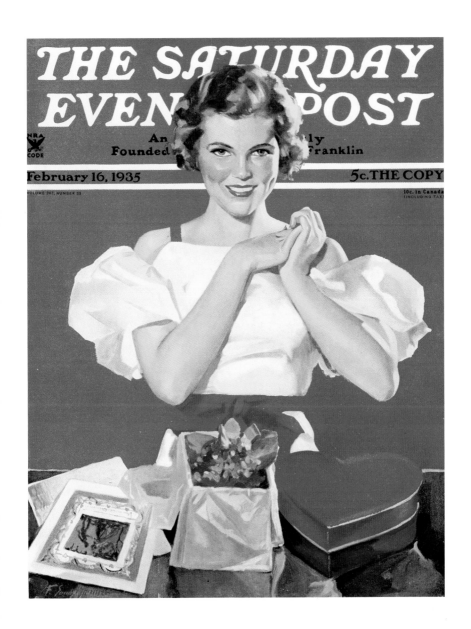

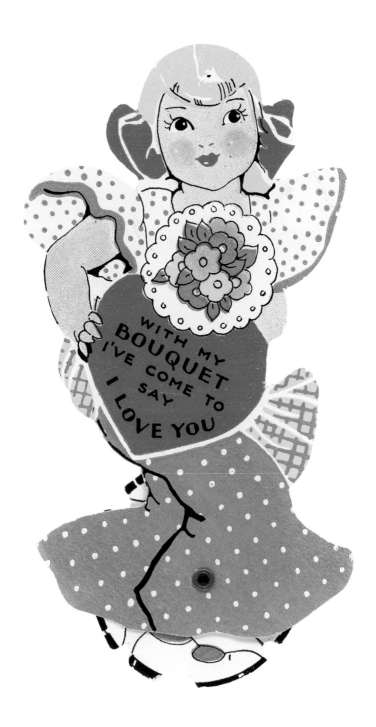

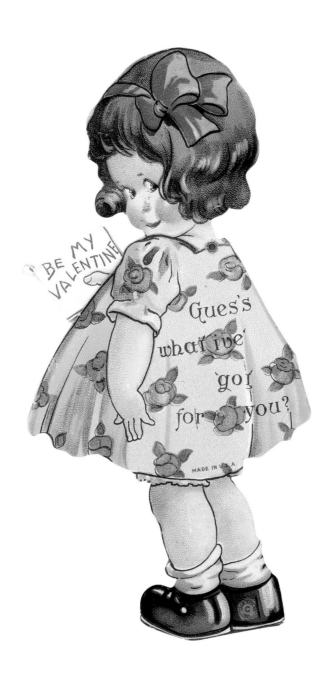

99

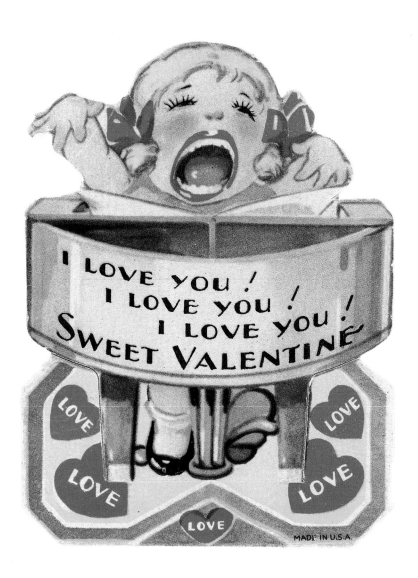

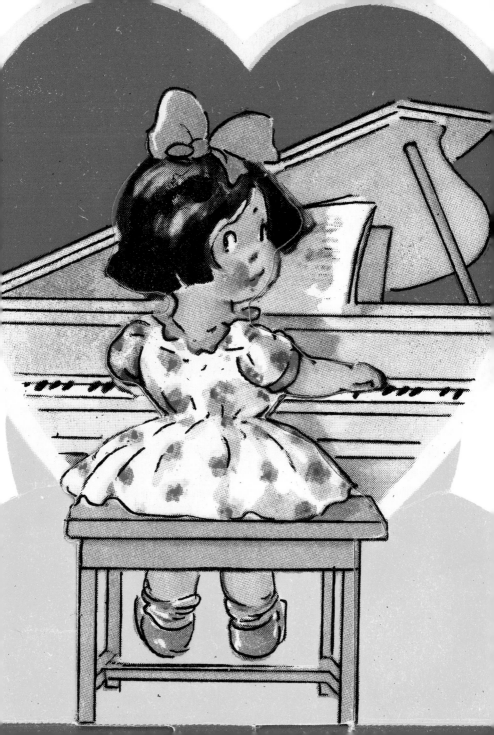

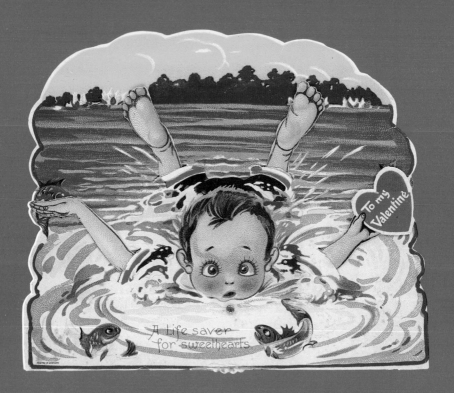

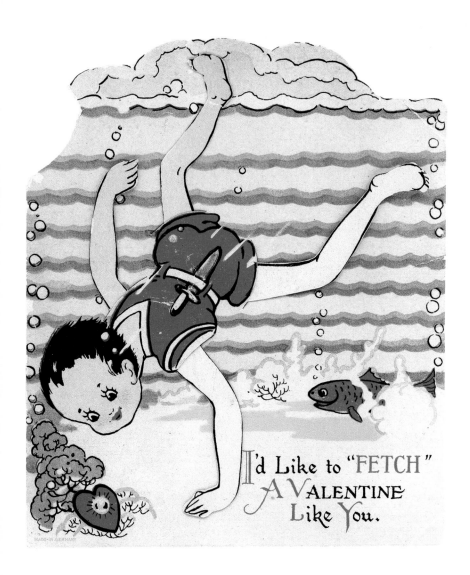

I'd Like to "FETCH"
A Valentine
Like You.

MADE IN GERMANY

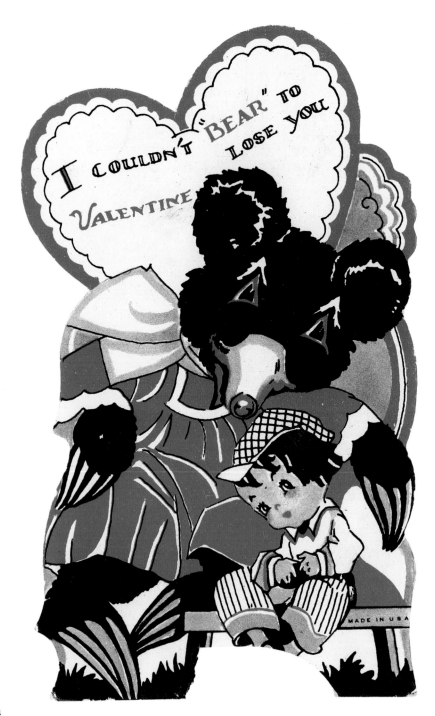

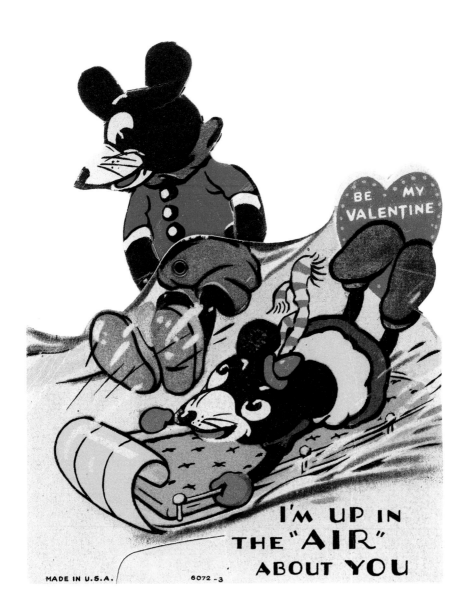

MADE IN U.S.A.　　6072-3

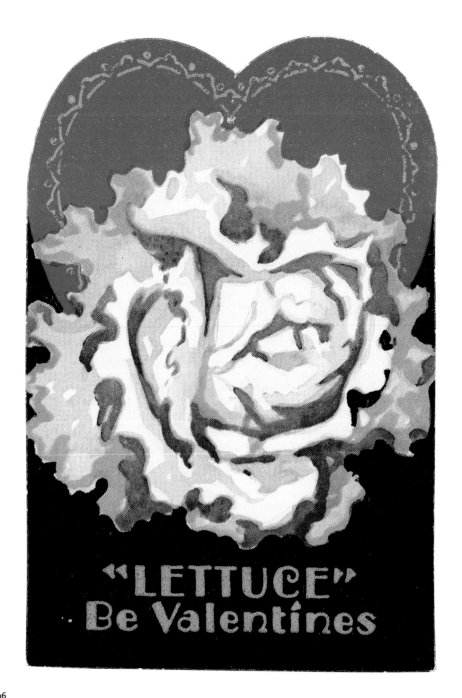

"LETTUCE"
Be Valentines

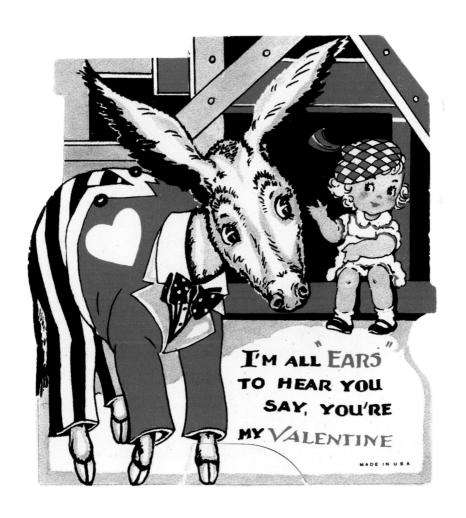

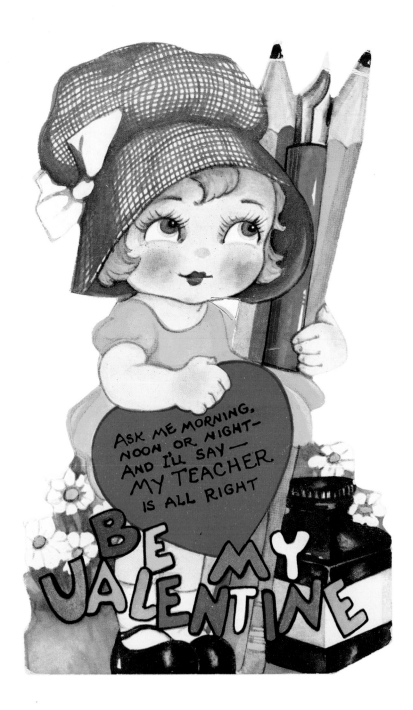

ASK ME MORNING, NOON OR NIGHT— AND I'LL SAY— MY TEACHER IS ALL RIGHT

BE MY VALENTINE

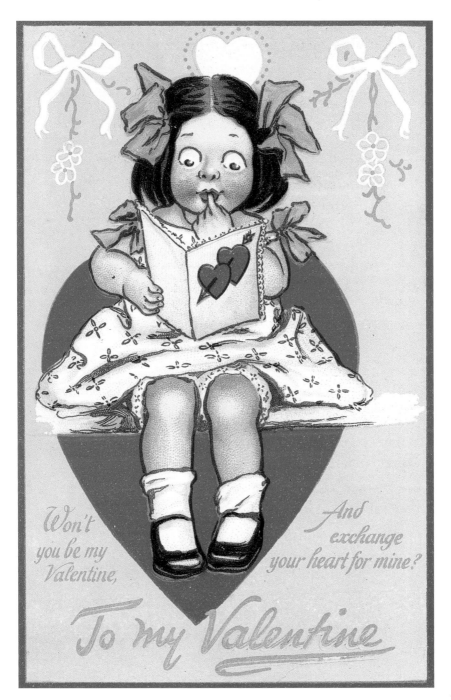

Won't you be my Valentine,

And exchange your heart for mine?

To my Valentine

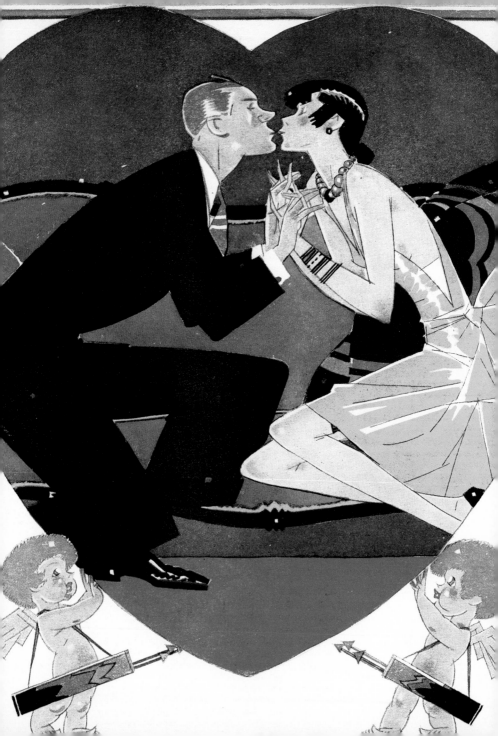

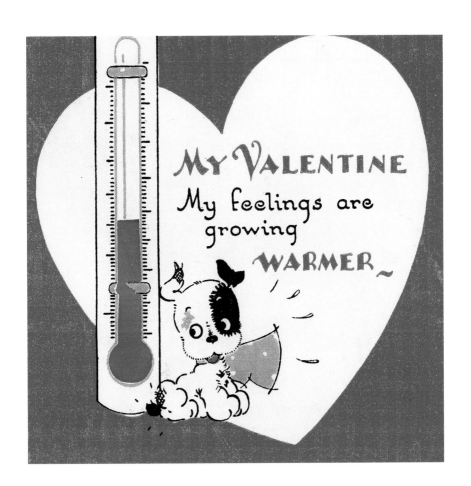

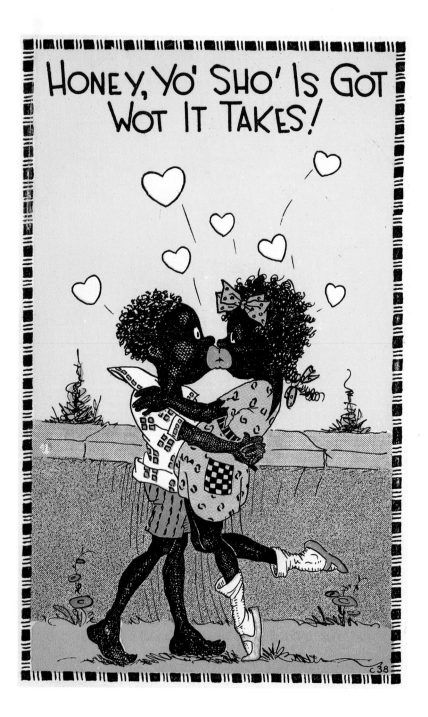

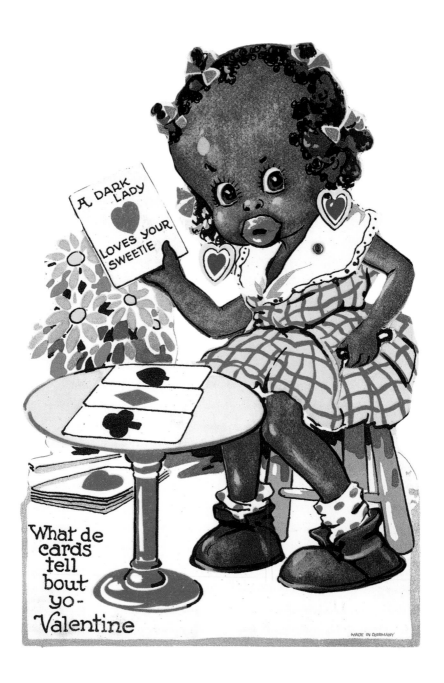

113

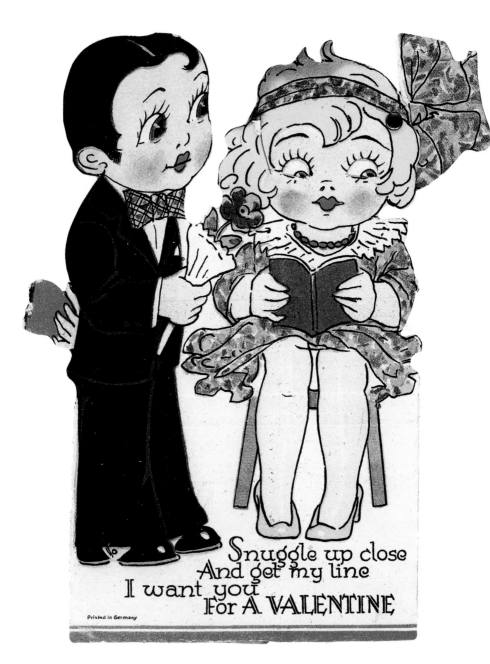

Snuggle up close
And get my line
I want you
For A VALENTINE

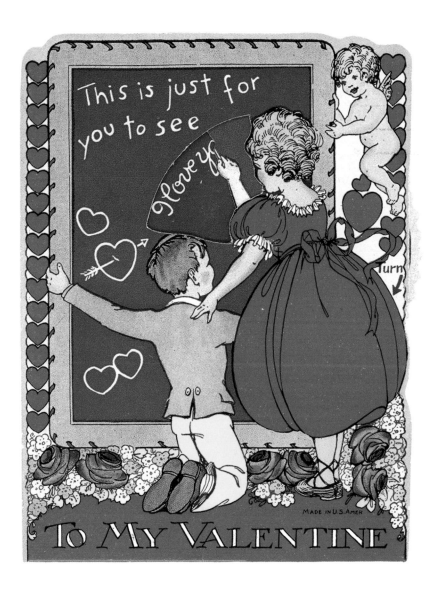

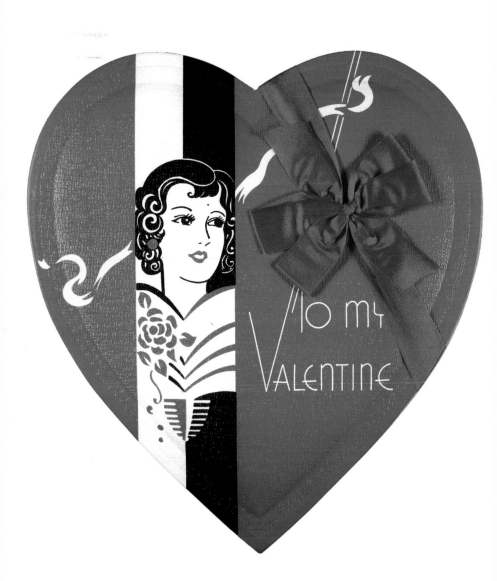

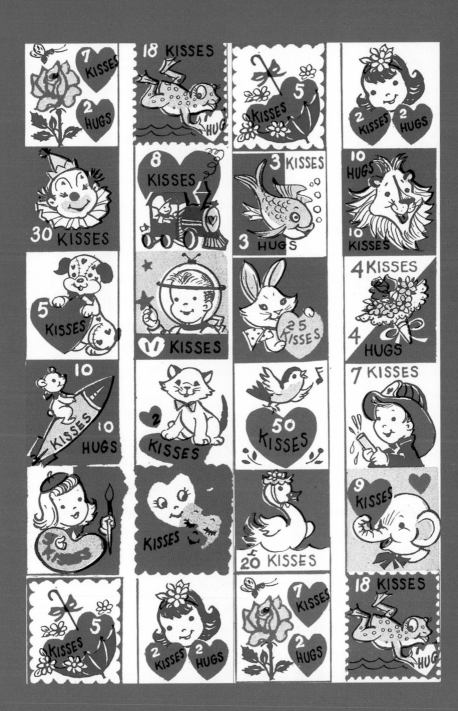

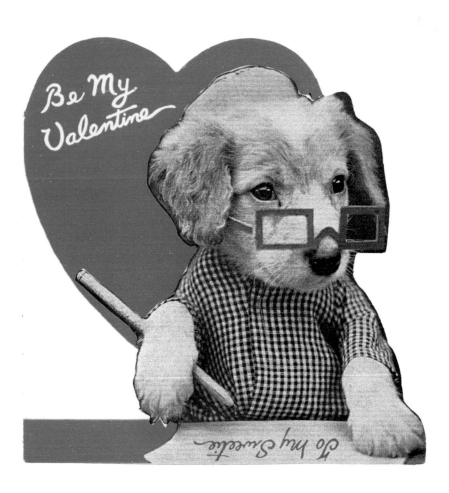

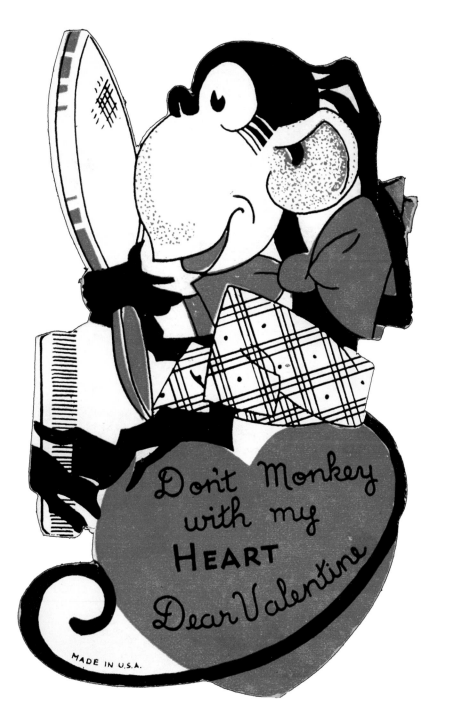

MADE IN U.S.A.

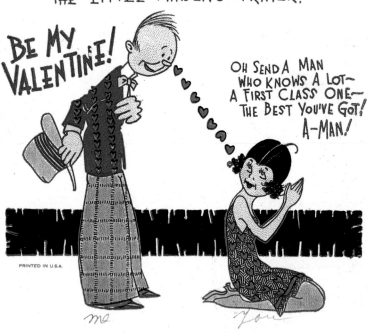

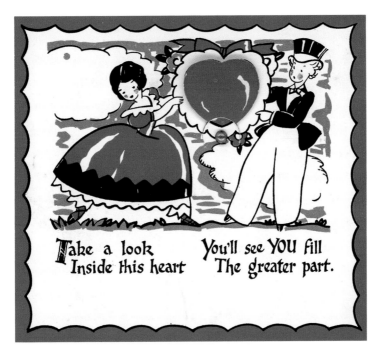

Take a look
Inside this heart

You'll see YOU fill
The greater part.

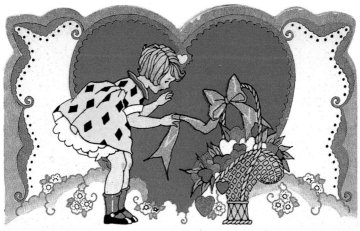

VALENTINE GREETINGS

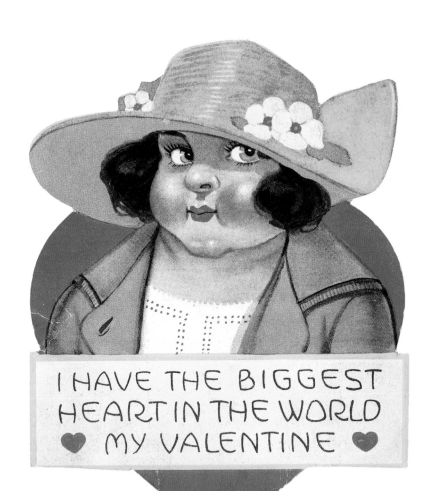

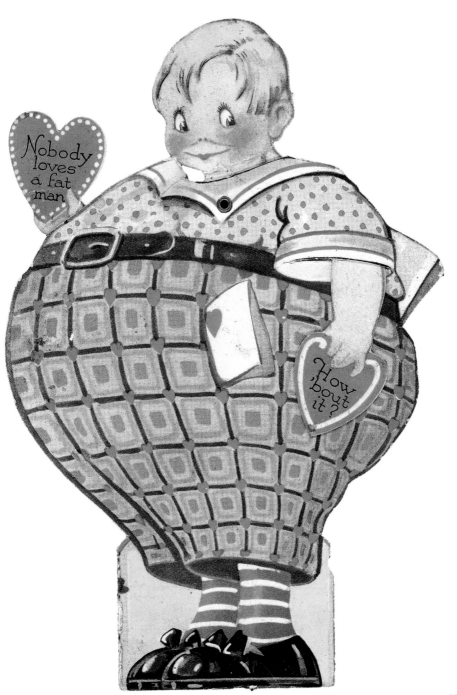

123

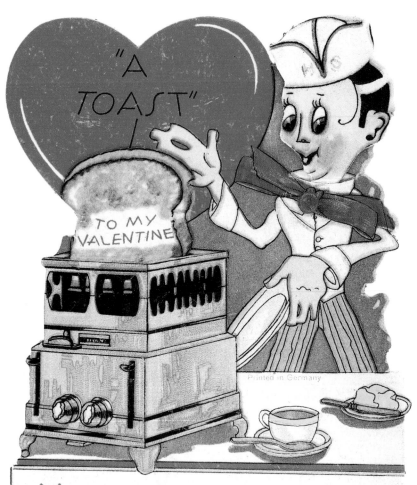

"A TOAST"

TO MY VALENTINE

YOU SURELY ARE WELL "BREAD" I KNOW THAT'S WHY I WANT YOU FOR MY "BOW"

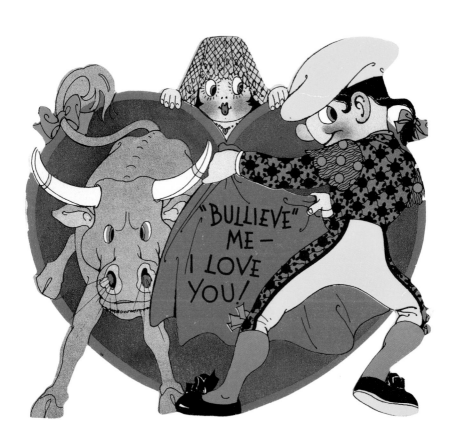

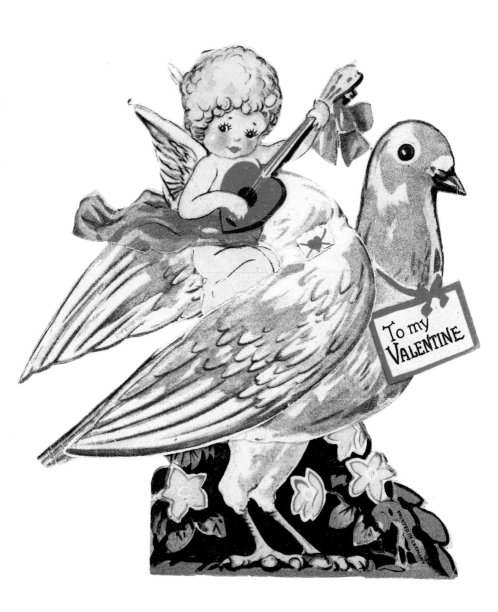

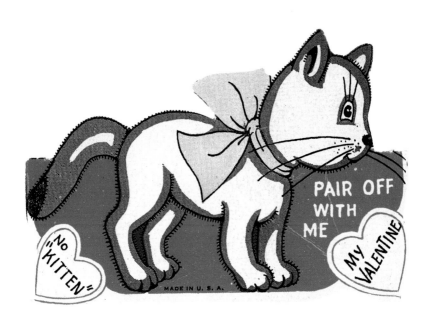

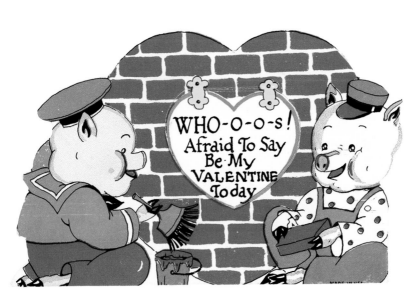

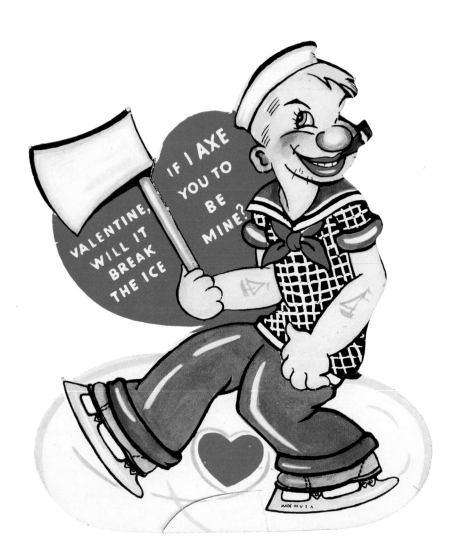

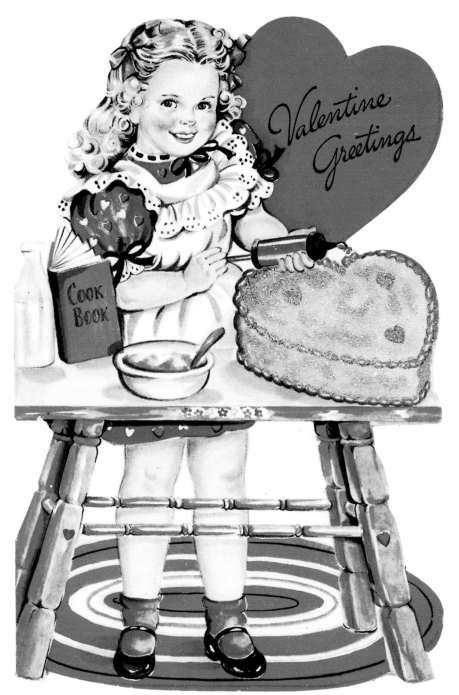

Valentine Greetings

COOK BOOK

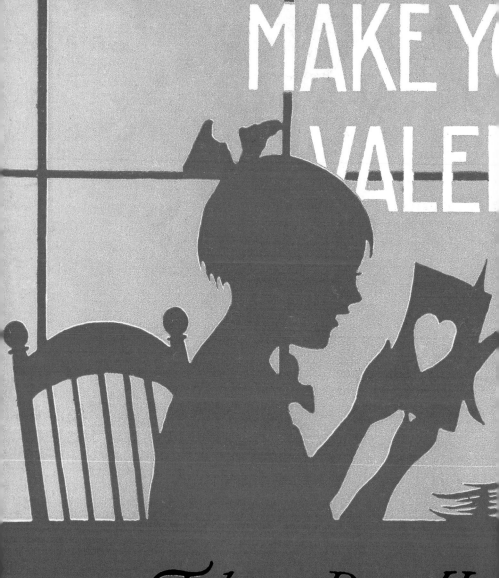

MAKE YO

VALE

Take a Box Ho

CONTAINS MATERIAL for 10 [

The GIBSON ART COMPA

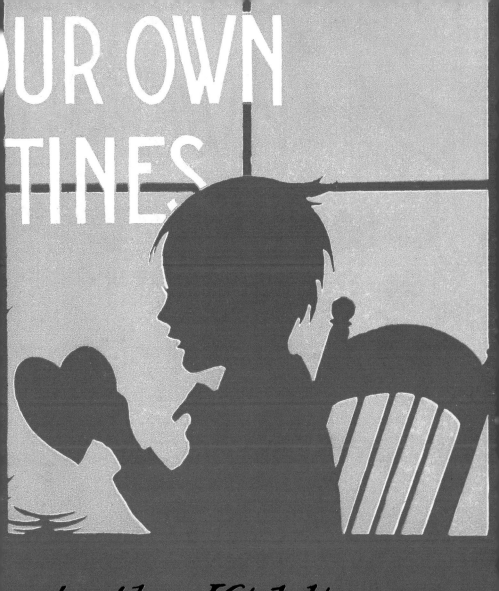

OUR OWN

TINES

e to the *Kiddies*

FFERENT & CLEVER VALENTINES

CINCINNATI, OHIO

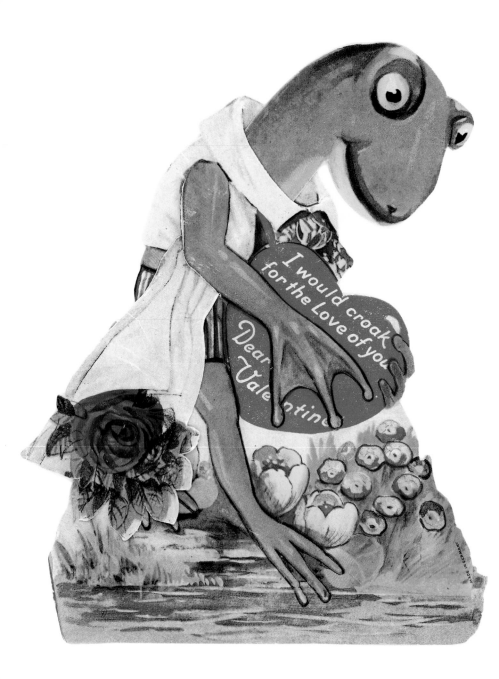

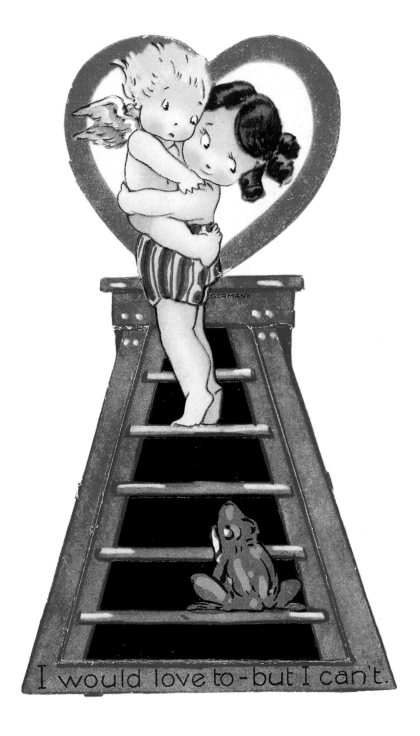

I would love to - but I can't.

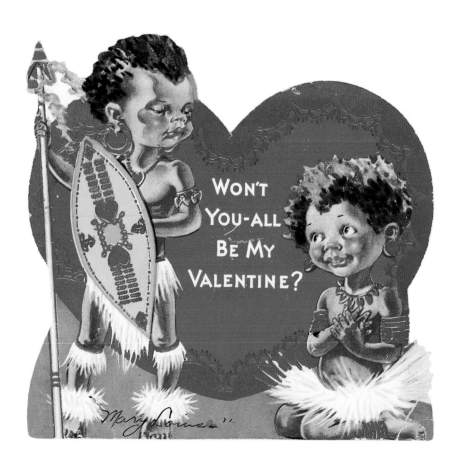

WON'T
YOU-ALL
BE MY
VALENTINE?

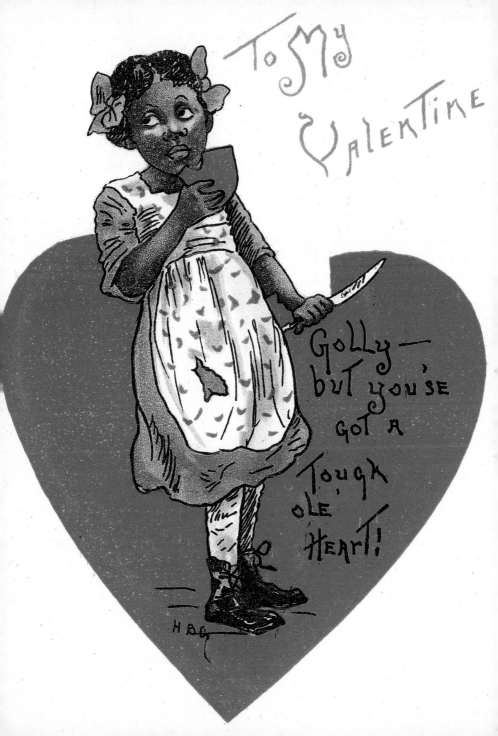

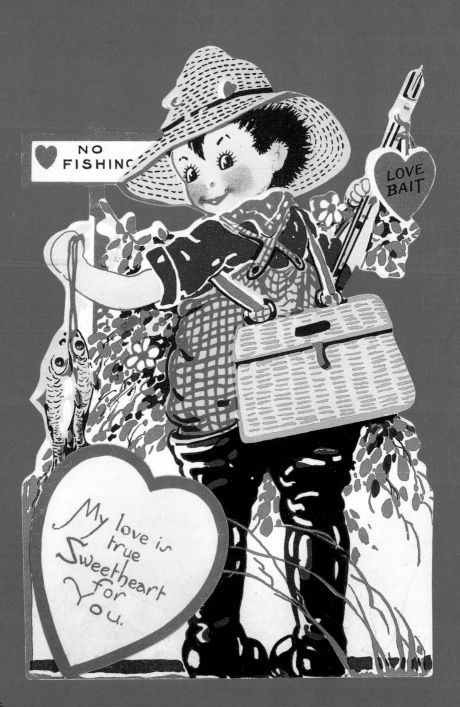

NO
FISHING

LOVE
BAIT

My love is
true
Sweetheart
for
You.

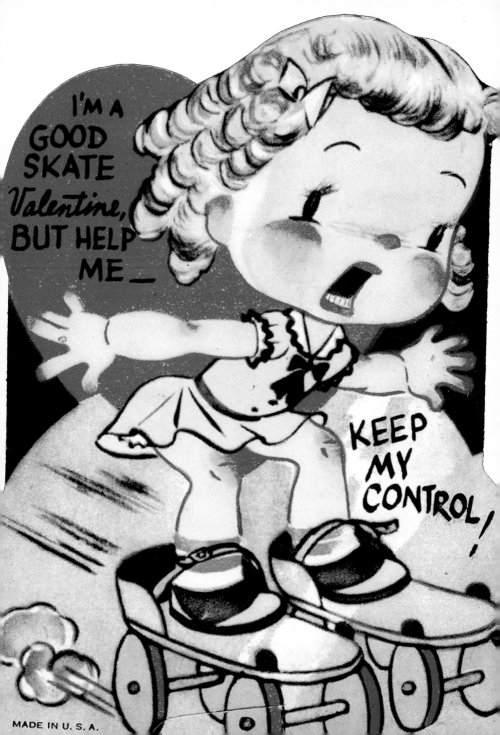

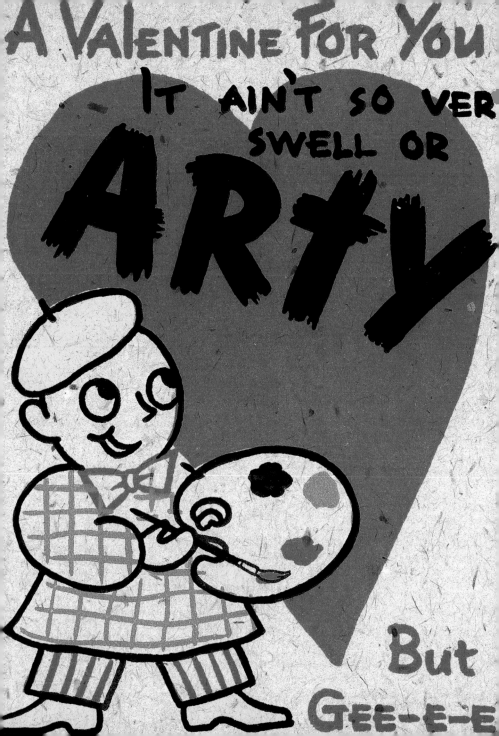

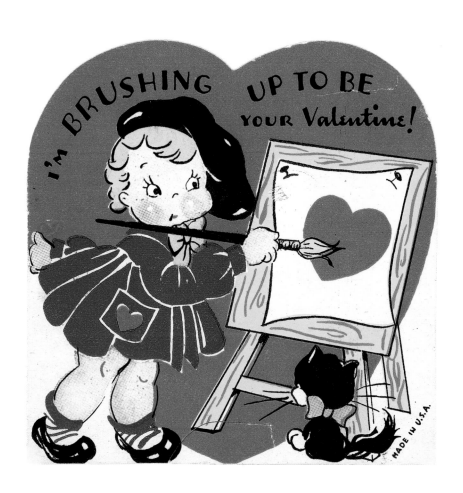

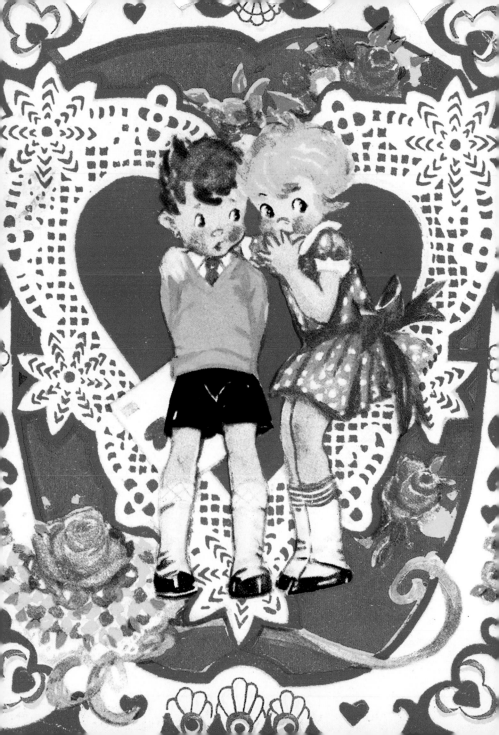

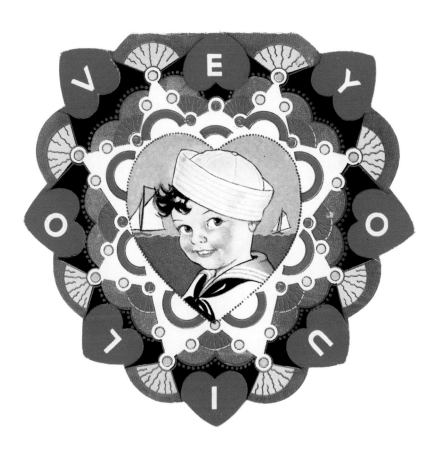

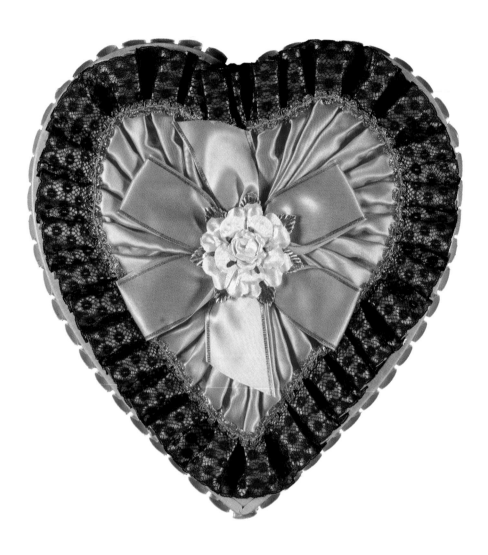

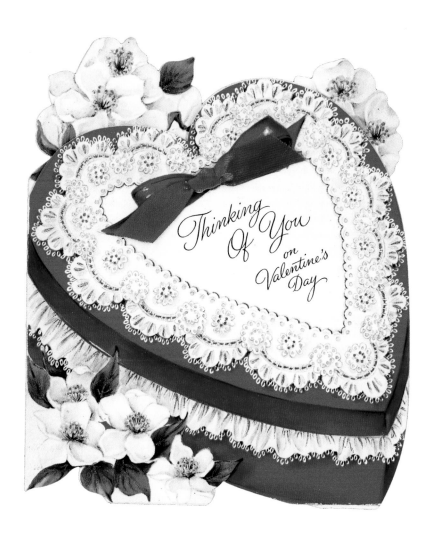

Wee Wisdom

A MAGAZINE FOR ~~BOYS AND G~~IRLS

FEBRUARY
1946

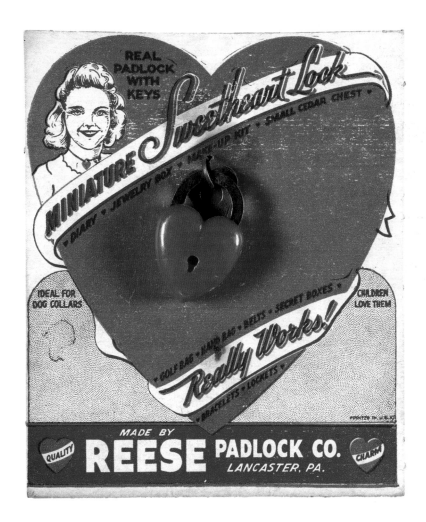

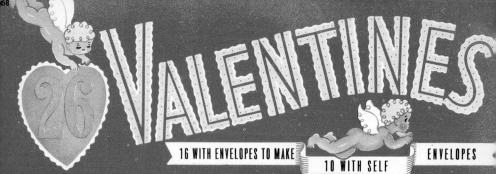

26 VALENTINES

16 WITH ENVELOPES TO MAKE **10 WITH SELF** **ENVELOPES**

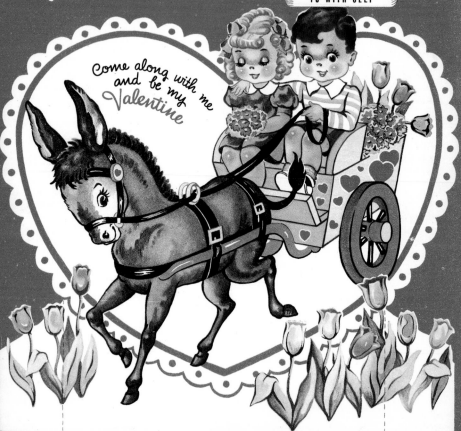

Come along with me
and be my
Valentine

FOLD BACK FOLD BACK

TO CUT— OUT AND MAKE UP

DOROTHEA J. SNOW

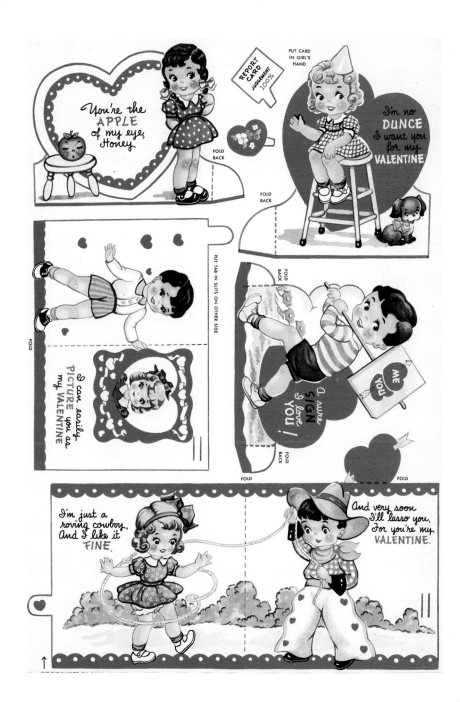

147

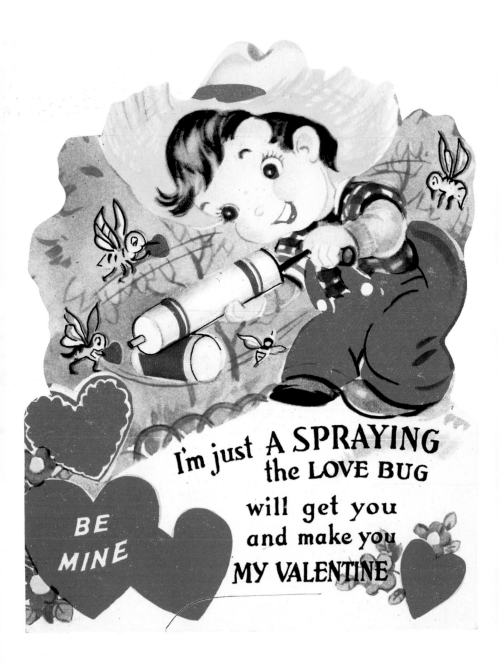

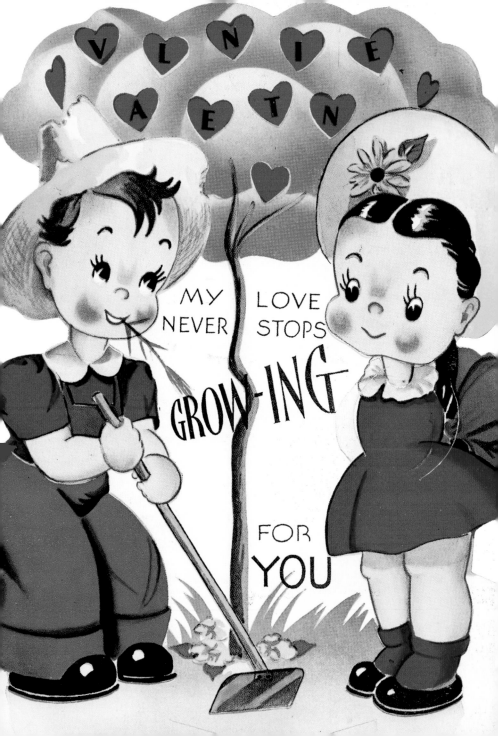

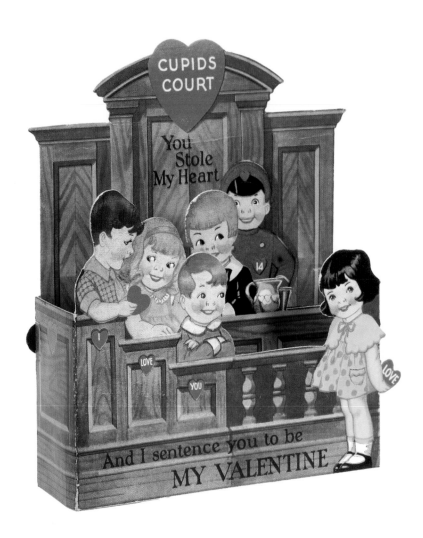

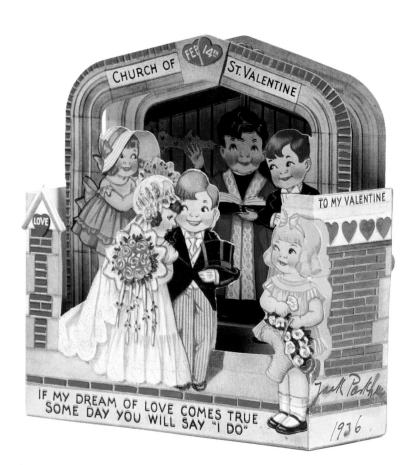

CHURCH OF · FEB 14TH · ST. VALENTINE

LOVE

TO MY VALENTINE

IF MY DREAM OF LOVE COMES TRUE
SOME DAY YOU WILL SAY "I DO"

Jack Parker
1936

WOMAN'S WORLD

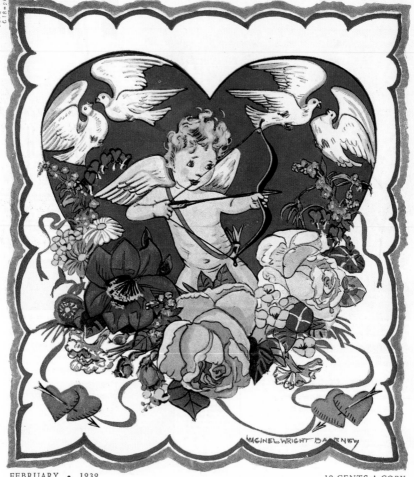

MACINEL-WRIGHT BARNEY

FEBRUARY • 1939

10 CENTS A COPY

"BAD BLOOD ON OLD *Powder Mountain*" *by* VINGIE E. ROE
Winter Care of Hands—Needlework—Gardening—Fashions—Cookery
WHAT YOU SHOULD KNOW *About the Washing of Accessories*

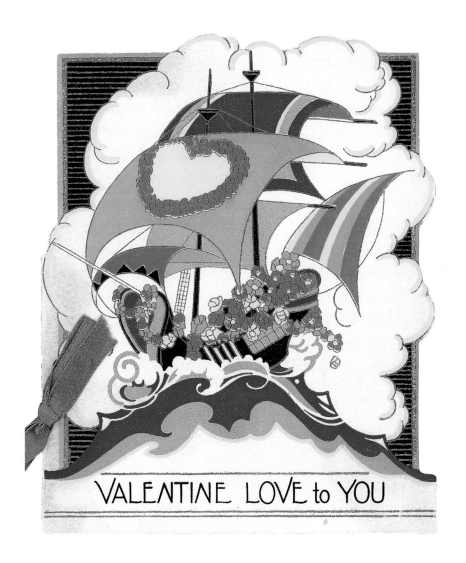

VALENTINE LOVE to YOU

THE SATURDAY EVENING POST

An ___ ___ ___tly
Founde ___ ___ Franklin

Volume 204, Number 33

10c. in Canada
(INCLUDING TAX)

February 13, 1932

5c. THE COPY

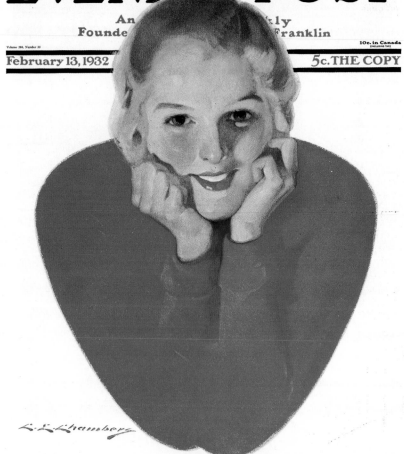

L. E. Chambers

To My Valentine

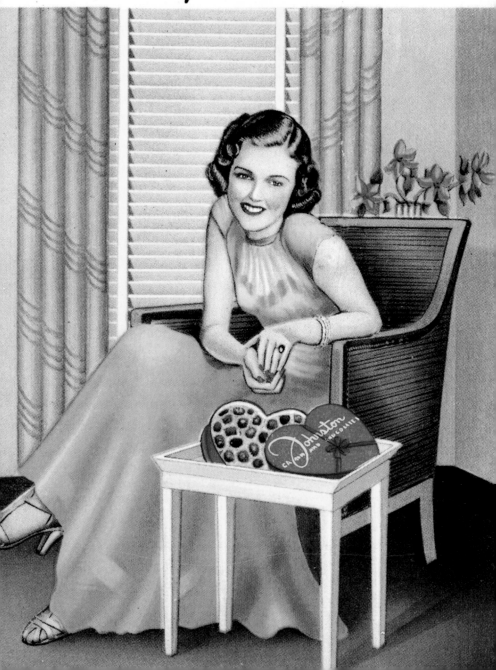

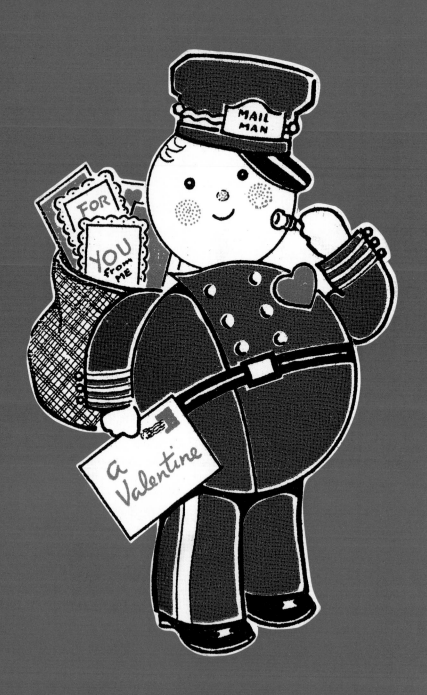

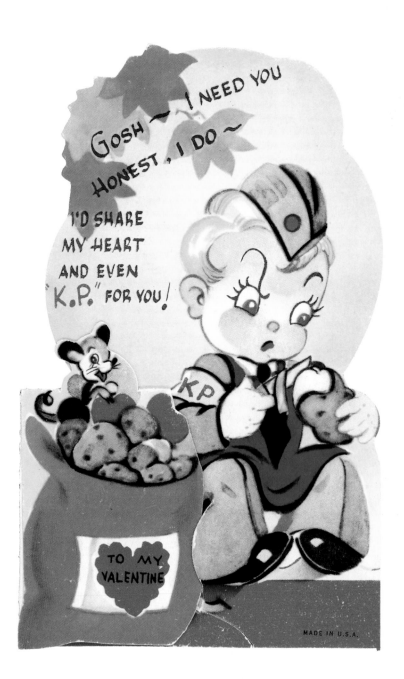

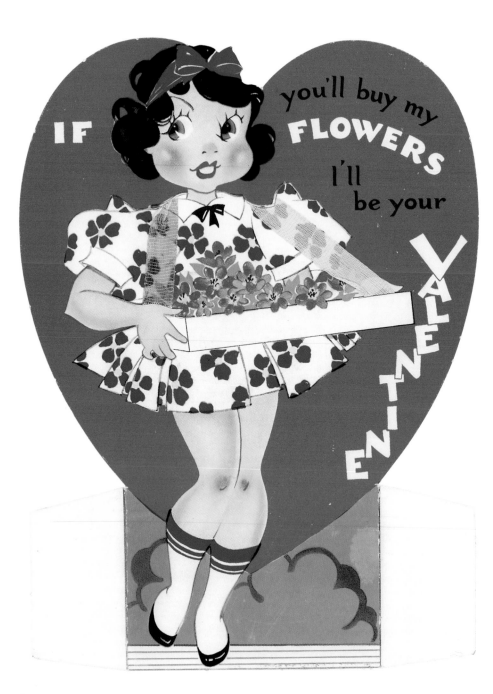

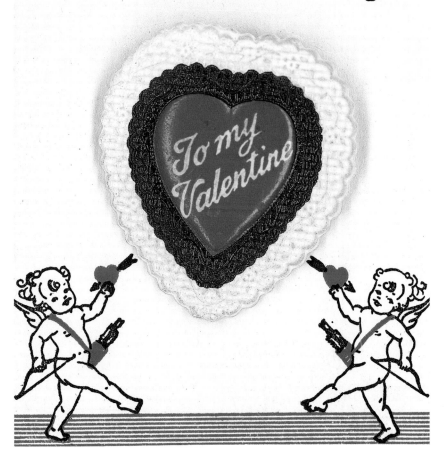

Valentine Greetings

To my Valentine

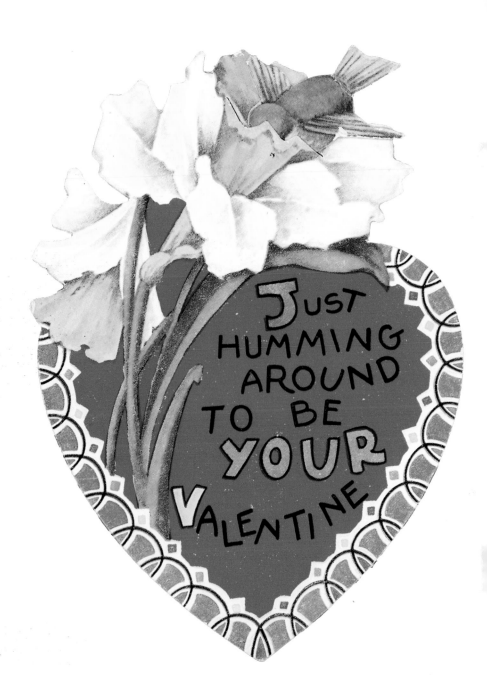

JUST HUMMING AROUND TO BE YOUR VALENTINE.

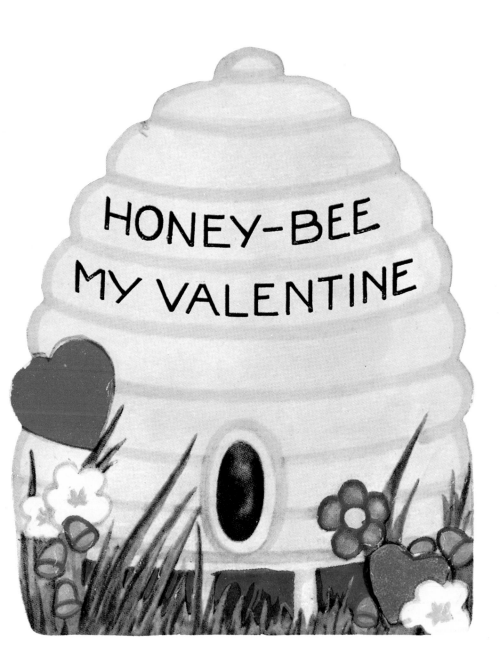

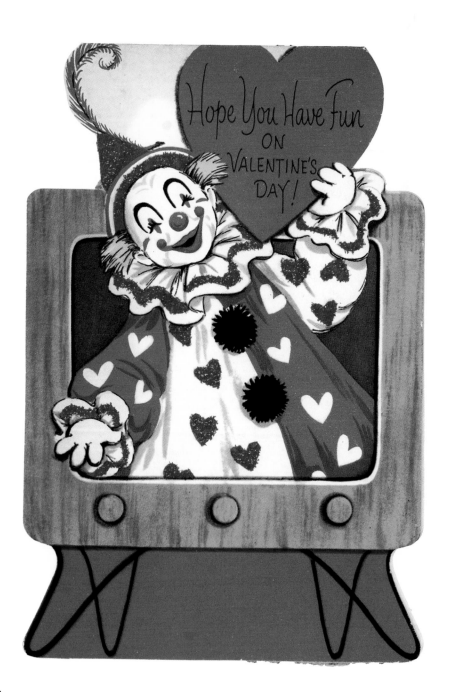

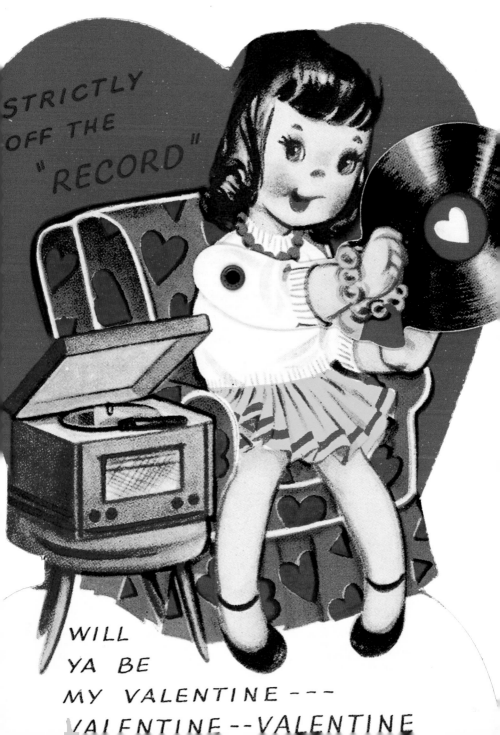

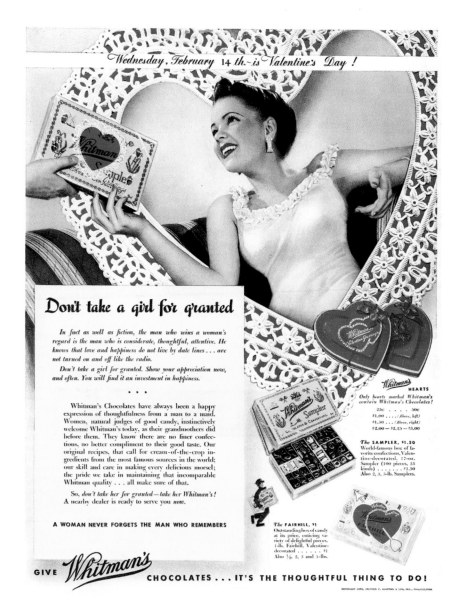

to my candy kid ... *FEB. 14, 1954*

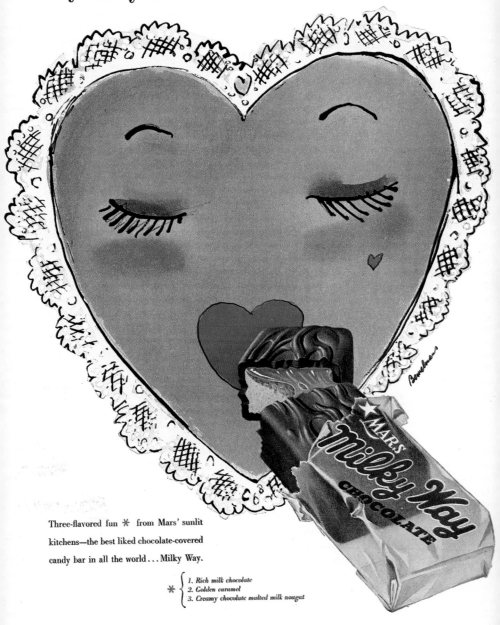

Three-flavored fun ✳ from Mars' sunlit
kitchens—the best liked chocolate-covered
candy bar in all the world...Milky Way.

✳ { *1. Rich milk chocolate*
2. Golden caramel
3. Creamy chocolate malted milk nougat }

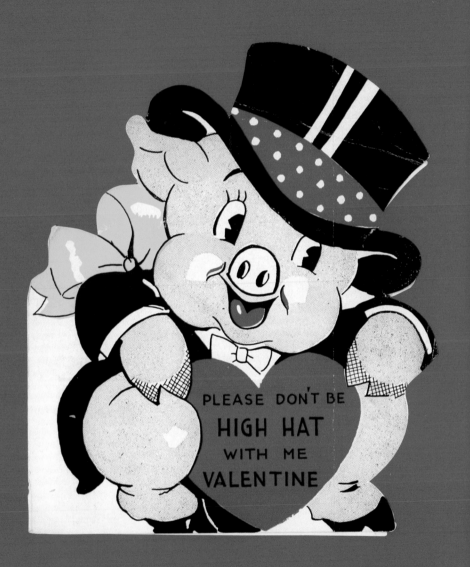

PLEASE DON'T BE
HIGH HAT
WITH ME
VALENTINE

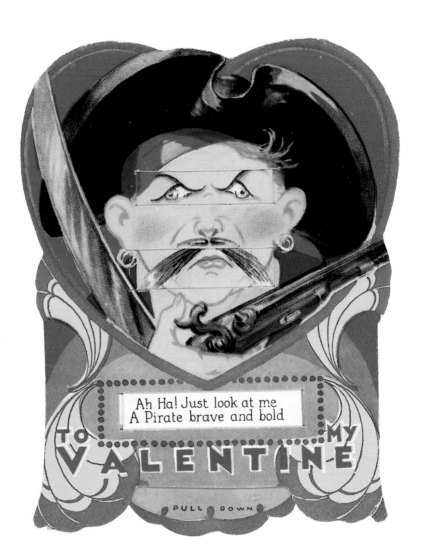

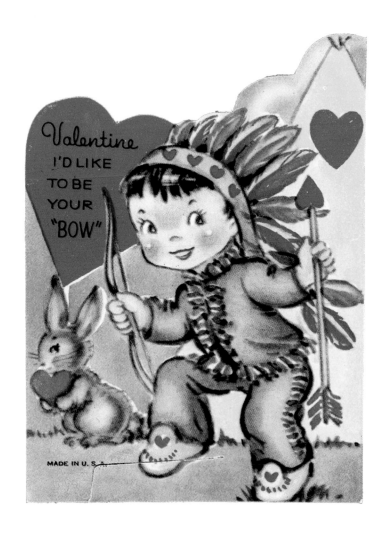

Valentine
I'D LIKE
TO BE
YOUR
"BOW"

MADE IN U. S. A.

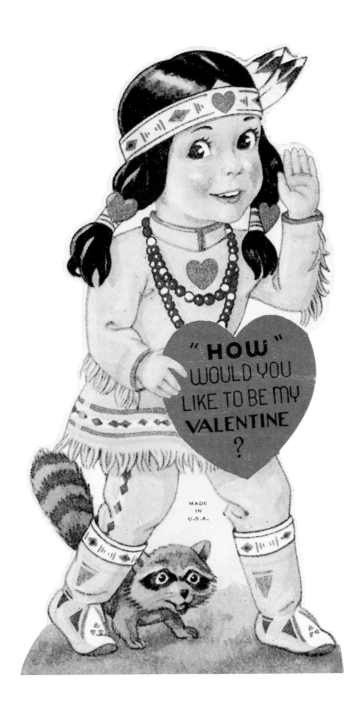

169

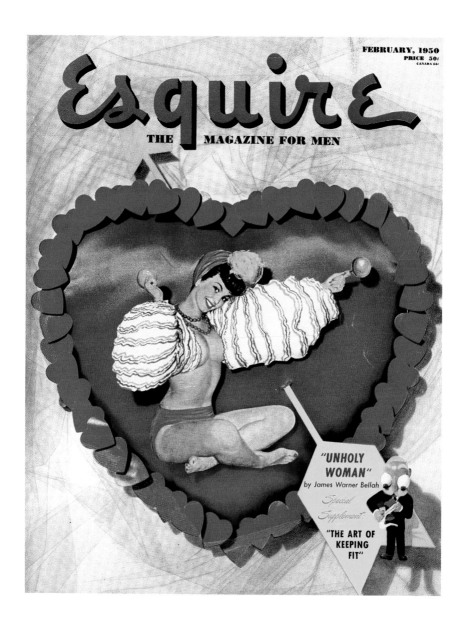

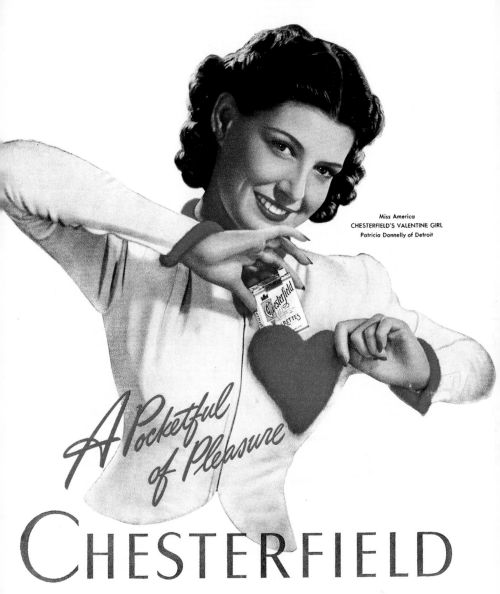

Miss America
CHESTERFIELD'S VALENTINE GIRL
Patricia Donnelly of Detroit

A Pocketful of Pleasure

CHESTERFIELD

The real reason why Chesterfields are in more pockets every day is because Chesterfield's Right Combination of the world's best cigarette tobaccos gives you a better smoke . . . definitely milder, cooler and better-tasting. *You can't buy a better cigarette.*

MAKE YOUR NEXT PACK CHESTERFIELD *They Satisfy*

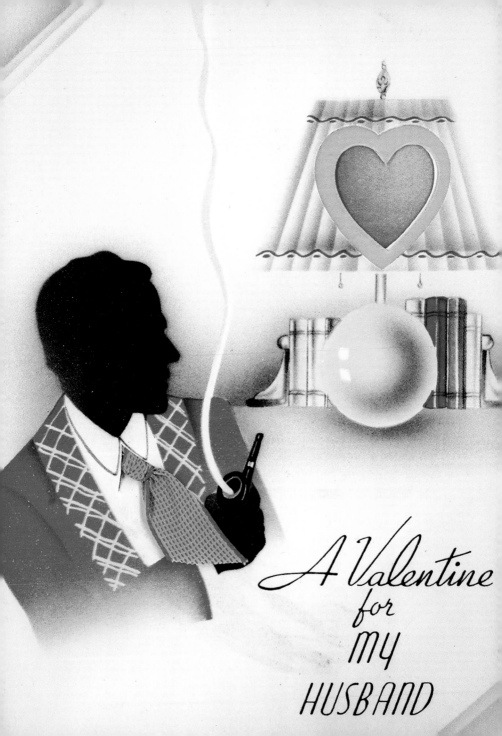

A Valentine for MY HUSBAND

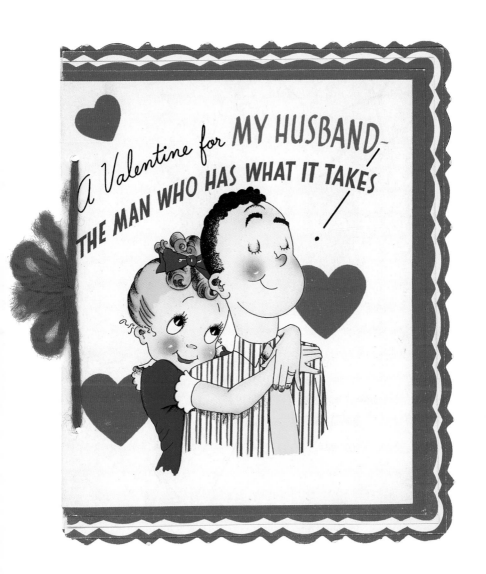

Straight from the heart!

Cupid can't miss with ammunition like this —shirts, ties, sport shirts, pajamas and socks* aimed straight and true at the man who *cares!* Colors and styles as fresh as a new romance—quality that stays faithful to the end. Stock your Valentine arsenal *now!* Phillips-Jones Corp., New York 1, N. Y.

Van Heusen
shirts • ties • pajamas • sport shirts

*These are a real Van Heusen scoop—the famous Wolsey 100% wool socks from the British Isles.

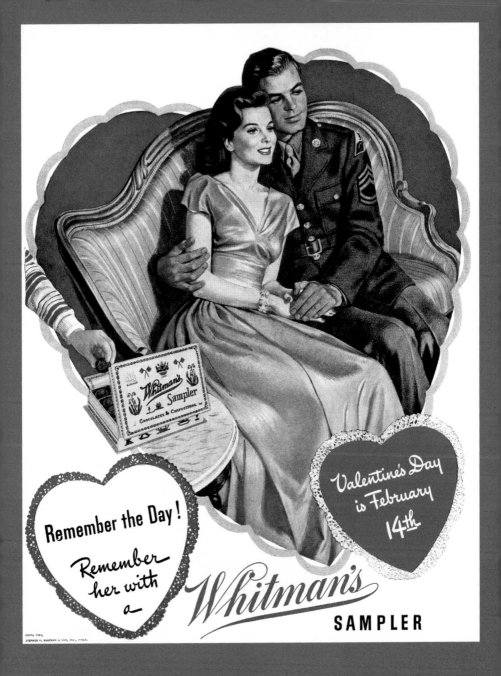

Remember the Day!

Remember her with a

Whitman's

SAMPLER

Valentine's Day is February 14th

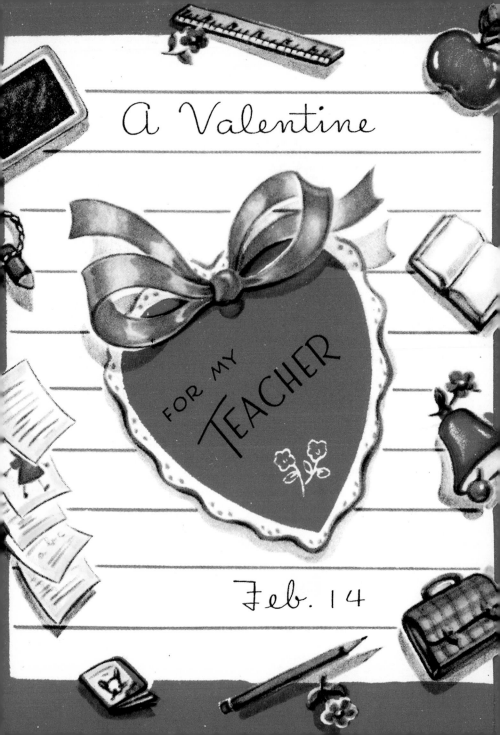

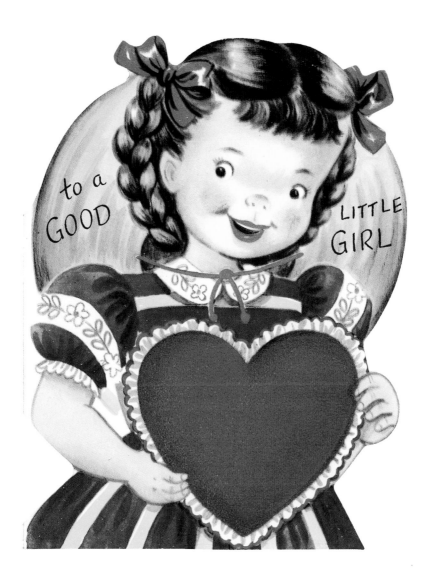

to a GOOD LITTLE GIRL

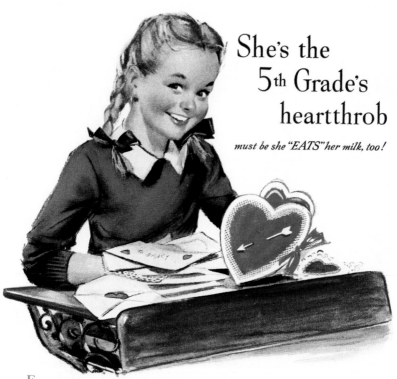

She's the 5th Grade's heartthrob

must be she "EATS" her milk, too!

Eyes are glued on her, when the Valentine Box is opened. Little boys' eyes, ardent and bashful. Little girls' eyes, wide with envy. And Teacher's eyes rueful. Why can't all little girls have this child's vivacity and charm?

A fairy godmother at the cradle always helps. But mothers can help, too. Because the health they guard, for their youngsters, goes hand in hand with charm.

It's easy to see that children get lots of pure, wholesome Carnation Milk. They can drink it, cold and mixed half and half with cold water. They can "eat" it, in any number of cooked or frozen dishes, that pad the day's milk quota.

Whichever way, all the valuable nutrients of finest milk are there, and homogenized for evenly distributed, rich tasting butterfat. Carnation is fine, whole cow's milk, enriched with vitamin D. Nothing is gone but part of the natural water.

Let *your* daughter be so well and happy she'll make small hearts flutter! Send for milk-rich recipes that point the way.

TRY IT FOR VALENTINE'S DAY!

For excitement—make a big red gelatin heart mold, cherry or raspberry flavor. For fine milk-rich nutrition, serve with it this wonderful sauce.

SOFT CUSTARD SAUCE
(Page 42, "Growing Up With Milk")

Scald 2 cups Carnation Milk, undiluted, in double boiler. Slightly beat 2 eggs with ¼ cup sugar, ¼ tsp. salt. Add some of the milk. Blend well. Add mixture to rest of milk. Mix. Cook over hot water, stirring constantly, till it coats a spoon. Flavor with 1 tsp. vanilla.

FREE! Big illustrated book of menus and recipes, planned to give all age groups nutritious, milk-rich meals. Let your child "eat" some of her milk! For "Growing Up With Milk," address Carnation Company, Dept. L18, Milwaukee, Wis., or Toronto, Ont., Can.

TUNE IN THE CARNATION "CONTENTED HOUR"
MONDAY EVENINGS, NBC NETWORK

IRRADIATED Carnation Milk
"FROM CONTENTED COWS"

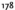

A Valentine
for a Nice
TEACHER

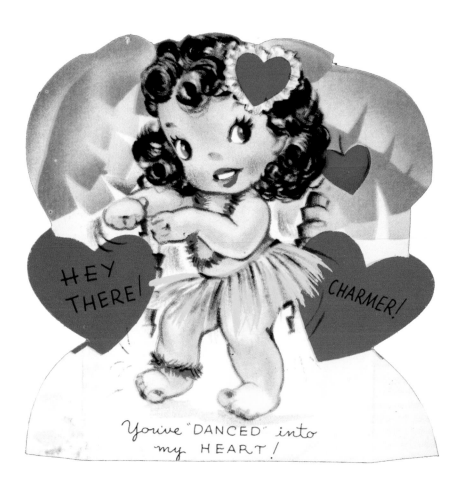

HEY THERE!

CHARMER!

You've "DANCED" into my HEART!

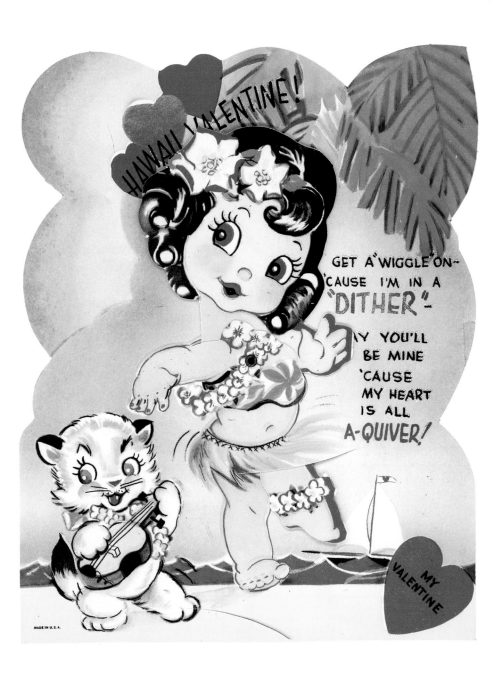

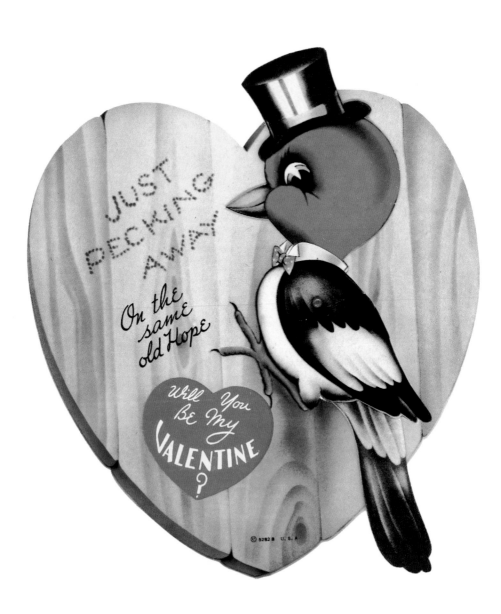

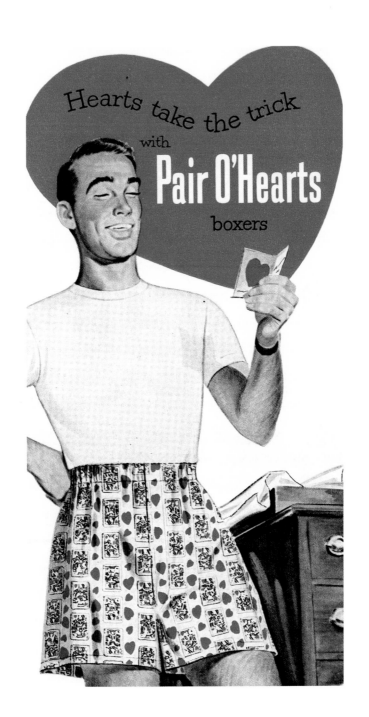

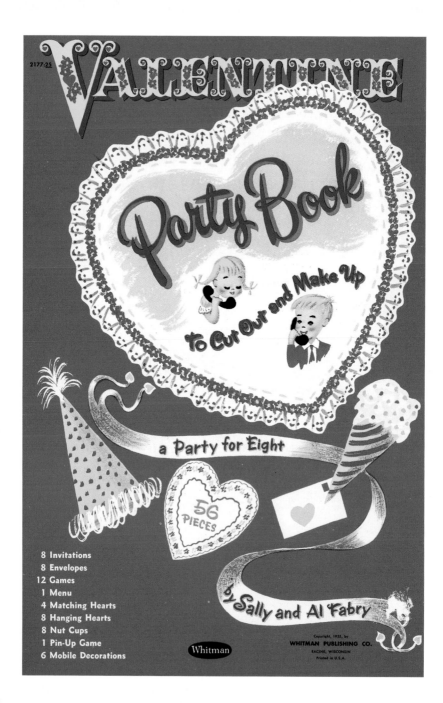

2177:25

VALENTINE

Party Book

To Cut Out and Make Up

a Party for Eight

56 PIECES

8 Invitations
8 Envelopes
12 Games
1 Menu
4 Matching Hearts
8 Hanging Hearts
8 Nut Cups
1 Pin-Up Game
6 Mobile Decorations

by Sally and Al Fabry

Whitman

Copyright, 1955, by
WHITMAN PUBLISHING CO.
RACINE, WISCONSIN
Printed in U.S.A.

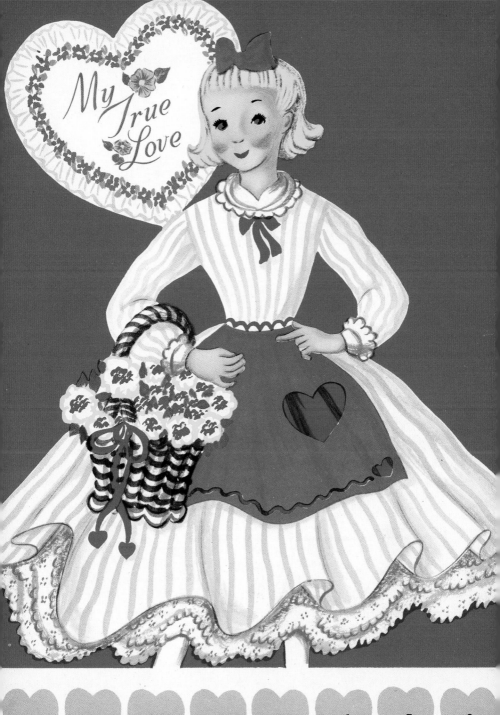

My True Love

1 2 3 4 5 6 7 8

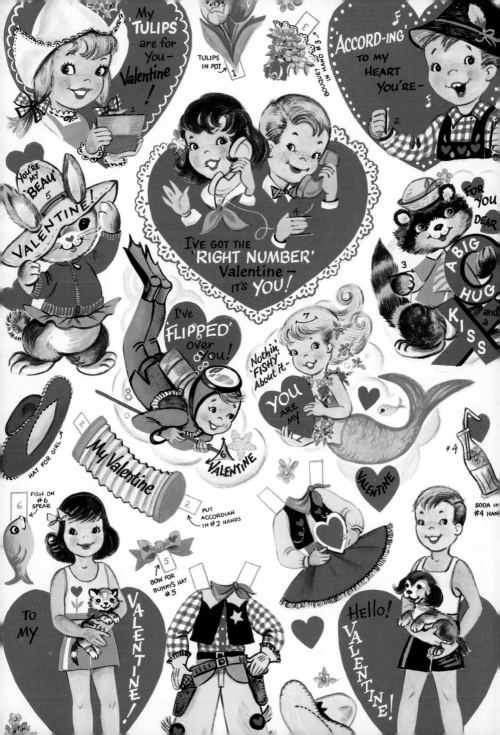

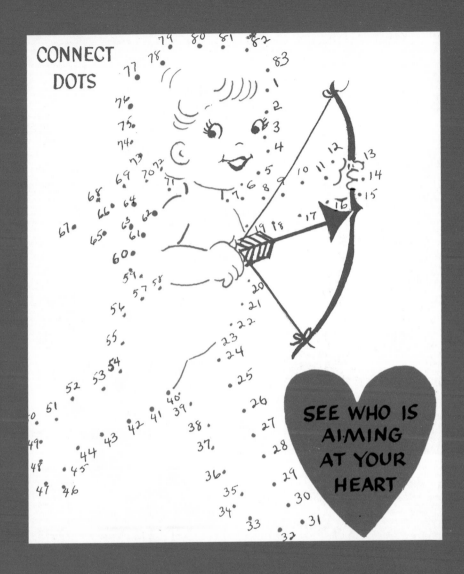

Acknowledgments

Producing the Icon series with such ease and speed would not have been possible without the help of a group of friends and colleagues whose interest, generosity, and enthusiasm makes these projects a true joy. Special thanks to Cindy Vance, Dan Goodsell, and Dan and Ruth DePalma for lending me items from their collections.

We'd like to whisper sweet nothings to author Steven Heller for being our valentine for yet another TASCHEN book. To our queen of hearts, managing editor Nina Wiener, thanks for keeping tabs on where Cupid's arrows land. A colossal box of chocolates to Cindy Vance for a sweetheart of a design and production job, and a bushel of valentines to our own editorial assistant Kate Soto and production manager Morgan Slade for all the love they put into this book.

All images are from the Jim Heimann collection unless otherwise noted. Any omissions for copy or credit are unintentional and appropriate credit will be given in future editions if such copyright holders contact the publisher.

Front cover: Postcard, 1918
Back cover: Card, 1926
Endpapers: Wrapping paper, 1924

© 2005 TASCHEN GmbH
Hohenzollernring 53, D–50672 Köln
www.taschen.com

Editor & art direction: Jim Heimann, Los Angeles
Digital composition & design: Cindy Vance, Modern Art, Los Angeles
Production: Morgan Slade, Los Angeles
Project management: Florian Kobler, Cologne
English-language editor: Nina Wiener and Kate Soto, Los Angeles
German translation: Anke Caroline Burger, Berlin
French translation: Lien, Amsterdam

Printed in Italy
ISBN 3-8228-4587-6

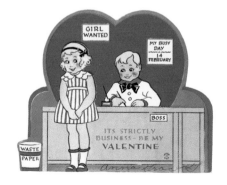

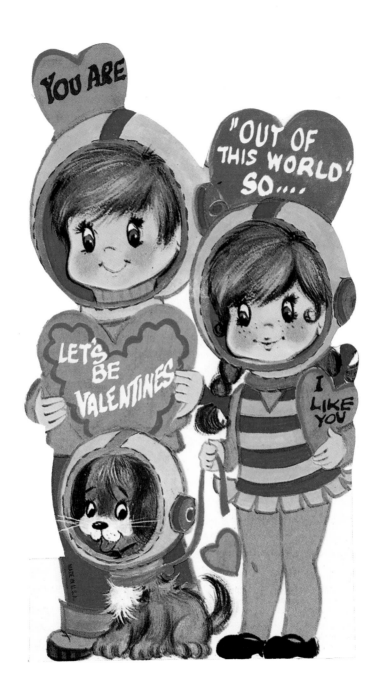

Christmas
Ed. Jim Heimann / Flexi-cover,
192 pp. / € 6.99 / $ 9.99 /
£ 4.99 / ¥ 1.500

Halloween
Steven Heller, Ed. Jim Heimann /
Flexi-cover, 192 pp. / € 6.99 /
$ 9.99 / £ 4.99 / ¥ 1.500

"These books are beautiful objects, well-designed and lucid." —*Le Monde*, Paris, on the ICONS series

"Buy them all and add some pleasure to your life."

African Style
Ed. Angelika Taschen

Alchemy & Mysticism
Alexander Roob

All-American Ads 40⁵
Ed. Jim Heimann

All-American Ads 50⁵
Ed. Jim Heimann

All-American Ads 60⁵
Ed. Jim Heimann

Angels
Gilles Néret

Architecture Now!
Ed. Philip Jodidio

Art Now
Eds. Burkhard Riemschneider,
Uta Grosenick

Atget's Paris
Ed. Hans Christian Adam

Berlin Style
Ed. Angelika Taschen

Chairs
Charlotte & Peter Fiell

Christmas
Steven Heller

Design of the 20ᵗʰ Century
Charlotte & Peter Fiell

Design for the 21ˢᵗ Century
Charlotte & Peter Fiell

Devils
Gilles Néret

Digital Beauties
Ed. Julius Wiedemann

Robert Doisneau
Ed. Jean-Claude Gautrand

East German Design
Ralf Ulrich / Photos: Ernst
Hedler

Egypt Style
Ed. Angelika Taschen

M.C. Escher

Fashion
Ed. The Kyoto Costume
Institute

HR Giger
HR Giger

Grand Tour
Harry Seidler,
Ed. Peter Gössel

Graphic Design
Ed. Charlotte & Peter Fiell

Greece Style
Ed. Angelika Taschen

Halloween Graphics
Steven Heller

Havana Style
Ed. Angelika Taschen

Homo Art
Gilles Néret

Hot Rods
Ed. Coco Shinomiya

Hula
Ed. Jim Heimann

Indian Style
Ed. Angelika Taschen

India Bazaar
Samantha Harrison,
Bari Kumar

Industrial Design
Charlotte & Peter Fiell

Japanese Beauties
Ed. Alex Gross

Krazy Kids' Food
Eds. Steve Roden,
Dan Goodsell

Las Vegas
Ed. Jim Heimann

London Style
Ed. Angelika Taschen

Mexicana
Ed. Jim Heimann

Mexico Style
Ed. Angelika Taschen

Morocco Style
Ed. Angelika Taschen

**Extra/Ordinary Objects,
Vol. I**
Ed. Colors Magazine

**Extra/Ordinary Objects,
Vol. II**
Ed. Colors Magazine

Paris Style
Ed. Angelika Taschen

Penguin
Frans Lanting

20ᵗʰ Century Photography
Museum Ludwig Cologne

Pin-Ups
Ed. Burkhard Riemschneider

Photo Icons I
Hans-Michael Koetzle

Photo Icons II
Hans-Michael Koetzle

Pierre et Gilles
Eric Troncy

Provence Style
Ed. Angelika Taschen

Pussycats
Gilles Néret

Safari Style
Ed. Angelika Taschen

Seaside Style
Ed. Angelika Taschen

Albertus Seba. Butterflies
Irmgard Müsch

**Albertus Seba. Shells &
Corals**
Irmgard Müsch

South African Style
Ed. Angelika Taschen

Starck
Ed Mae Cooper, Pierre Doze,
Elisabeth Laville

Surfing
Ed. Jim Heimann

Sweden Style
Ed. Angelika Taschen

Sydney Style
Ed. Angelika Taschen

Tattoos
Ed. Henk Schiffmacher

Tiffany
Jacob Baal-Teshuva

Tiki Style
Sven Kirsten

Tuscany Style
Ed. Angelika Taschen

Web Design: Best Studios
Ed. Julius Wiedemann

Women Artists
in the 20ᵗʰ and 21ˢᵗ Century
Ed. Uta Grosenick

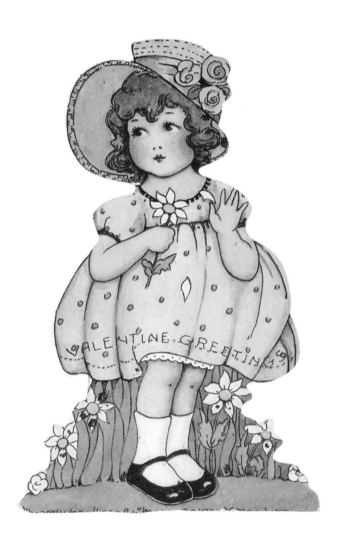

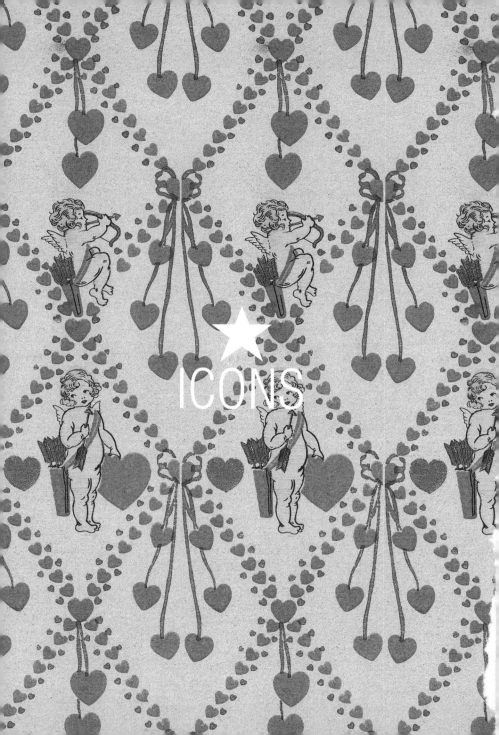